Red Lipstick

Red Lipstick

AN ODE TO A BEAUTY ICON

Rachel Felder

HARPER
DESIGN
An Imprint of HarperCollinsPublishers

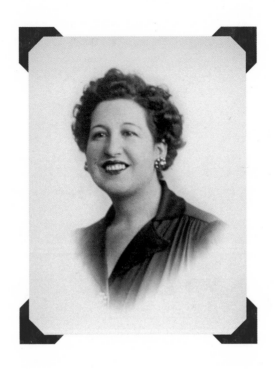

For my beloved grandmother
MILLIE FELDER,
who appreciated everything stylish,
especially red lipstick.

CONTENTS

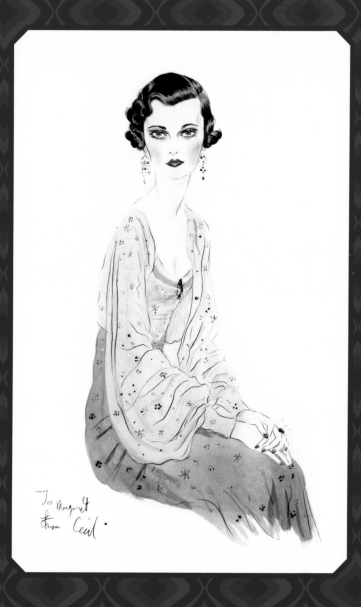

INTRODUCTION

OF ALL THE STRIKING MAKEUP ITEMS THAT WOMEN rely on—inky black mascara, eye-defining liners, powders and creams and gels to contour, conceal, and accentuate—nothing has the intense power of red lipstick. Vivid, charismatic, and eye-catching, it's feminine but never demure. Sensual, glamorous, and sophisticated, it's a bold communicator, telegraphing self-assurance and strength—and, in some contexts, defiance—without uttering a word.

For some, red lipstick is reserved for special, dressed-up occasions, like a holiday party or big date. For others, it's the ultimate power accessory to wear to meetings, a bold flourish that commands attention, underlines authority, and bolsters confidence—a foil to insecurity. And then there are the devotees: those women for whom wearing it consistently is a part of their identity, if not a signature.

One of red lipstick's many alluring qualities is that it's universally flattering. It looks great on blondes, brunettes, redheads, and women with gray hair; it's as well suited to dark complexions as fair ones. It makes both pale and dark eyes sparkle. It works on women from eighteen to eighty. "It's the default color of lipstick," says makeup artist Dick Page, a backstage mainstay. "It's a neutral."

A love of red lipstick in all its nuanced shades—scarlet, cherry, Bordeaux, and beyond—is nothing new. Red lip coloring has been beloved by women for many centuries, albeit in forms different from the ubiquitous bullet-shaped tubes that are synonymous with lipstick today. It's been made from ingredients that have been at

various times natural, chemical, moisturizing, and toxic; it's been coveted and outlawed. Its various incarnations have been messy, gloppy, oily, and expensive, but nonetheless, it has still garnered a following, thanks to rich color payoff at the end. Today, of course, the evolution in makeup formulation and packaging has made applying lipstick easy to do wherever you are.

But the pleasure of wearing red lipstick is not just about the look. Applying it is a sensuous experience for all, a beloved ritual

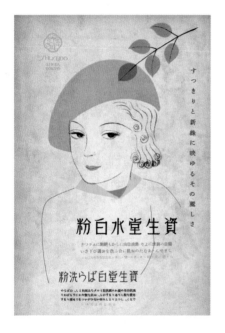

by many, and it's a commitment. Red lipstick asks for reverence, which makes sense considering what it bestows in return. One must honor its power by not only taking the time and care to apply it properly, but to wear it with an eye to upkeep. No self-respecting red lipstick is a last-minute date or the kind of girl who is inclined toward casual relationships: she does not take kindly to being swiped on and has a deep distaste for being diminished to a thin ring of color around the mouth.

Effort is required to get the application just right, but that's part of the pleasure too—the familiar weight of a favorite tube, chubby crayon, or pot in your hand, and the singular concentration of applying the color well, then outlining the lips with pencil or, as some prefer, filling them in completely, then reapplying the color. Blotting, reapplying, adjusting the line, even sealing with a translucent powder for a long evening—all of this adds up to an empowering ritual no demure pink or soft beige can match.

As unforgiving as applying red lipstick can be, it is well worth the effort, for red is transformative; each little hit of a color brings with it greater self-assurance, sexiness, glamour, magnetism, beauty, and authority.

Red lipstick has been one of my great passions—a beloved obsession, really—for many years. The addiction began when I was a teenager, mostly as a rebellious statement during a time when neutral, understated lipstick was in fashion and never looked quite right on my full-lipped, center-of-attention mouth. In a sense, bold and highly pigmented red lipstick was my cosmetic equivalent of a black leather motorcycle jacket or spiked-up hair, my two other obligatory accessories at the time. Red lips made me feel strong and passionate; armed with my carmine mouth, I was ready to be noticed and seen as a nonconformist individual. Come to think of it, that's the way I still feel when I swipe on my lipstick today.

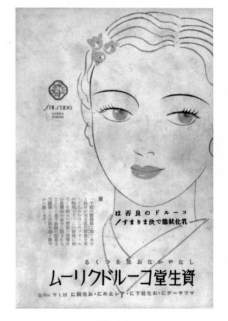

Over the years, red lipstick has become my trademark, at once a uniform, crutch, beautifier, mask, fashion statement, loyal companion, and reliable accessory. It's the ultimate cosmetic finishing step, and one that I can't go without any day. It's become an essential part of who I am and is part of the way I define and present myself to the world. It's a virtual tattoo that is reapplied daily but feels decidedly permanent despite coming off with a bit of makeup remover and a cotton ball.

A few decades of personal adoration in, red lipstick isn't just my off-duty fixation: as a journalist who's written extensively about beauty, it's a subject I've researched and examined and quizzed experts on for many years. It seems like there are always new things to discover, from hidden historical facts to the way a fabulously long-lasting deep cerise was created. That fascination has also included a quest to track down every new red lipstick out there, to check out a new formulation, or type of packaging, or hue that's just ever so slightly bluer or yellower or more burgundy than the one I'm wearing at that very moment.

This book is an homage to my most favorite accessory. What follows includes both red lipstick's history and its context within that storied past, little-known details about the many formidable women who have loved it, and even a few tricks I've learned along the way about choosing the most flattering shades and formulations. The book is also a visual celebration, with a selection of paintings, illustrations, photographs, and advertisements that conveys its enduring beauty and power, from the earliest civilizations to the present day and, I'm sure, well into the future. My devotion to red lipstick is eternal; my allegiance, unalterable. My hope is that this small volume ignites the same passion in you.

Musings

You know how to whistle,
don't you, Steve? You just put
your lips together and . . . blow.

—LAUREN BACALL
as Slim Browning in
To Have and Have Not (1944)

HOLLYWOOD GLAMOUR

With its sublime A-list allure, red lipstick has long been the makeup essential of red carpets, award shows, and black-tie galas. Swiping on a coating of crimson taps into the star power, captivating elegance, and *je ne sais quoi* associated with the actresses of what's become known as the Golden Age of Hollywood, which began in the late 1920s as silent pictures gave way to talkies and faded out in the late 1950s with the decline of the studio system and the rise of television and its prevalence as a source of entertainment in people's homes.

For the almost thirty years in between, Hollywood stars represented a feminine ideal, even though many of their looks were studio-altered with makeup, as well as other procedures, to create enviable attributes, from a more refined jaw to a higher hairline. Whatever the transformation, the ultimate look was one of perfectly groomed beauty: glossy hair, precisely plucked eyebrows, and a prominent mouth coated with fastidiously applied, just-shiny-enough red lipstick. The look produced a slightly remote, enigmatic appeal that radiated stardom, making it even more covetable to women worldwide.

Many of the era's most memorable female stars—like Hedy Lamarr, Dorothy Lamour, Jean Harlow, Rita Hayworth, Marlene Dietrich, and Joan Crawford—wore red lipstick almost singularly, and to great effect. Their crimson lips were a key component of a lofty public persona, one that made them admired for their appearance, success, and fame.

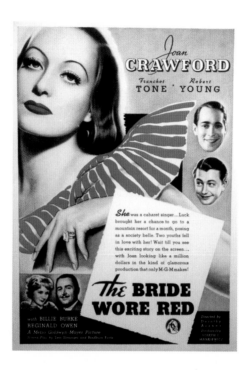

During those years, red lipstick was very much a part of the fashion and beauty sensibility, infusing glamour into women's everyday look, whether they were full-time housewives or part of the expanding workforce. Crimson-lipped actresses helped fuel that cultural ubiquity, as they favored wearing red lipstick on-screen, even when playing roles in period films where it wasn't historically correct. When Vivien Leigh played Scarlett O'Hara in *Gone with the Wind,* she wore perfectly applied red lipstick, even though the story is set during the American Civil War. "Whether or not the lips are red really depends on the fashion of the time," explains Deborah Nadoolman Landis, founding director of the David C. Copley Center for the Study of Costume Design at UCLA's School of Theater, Film and Television. "Lips tended to be red when the audience was wearing red lips, no matter what was happening."

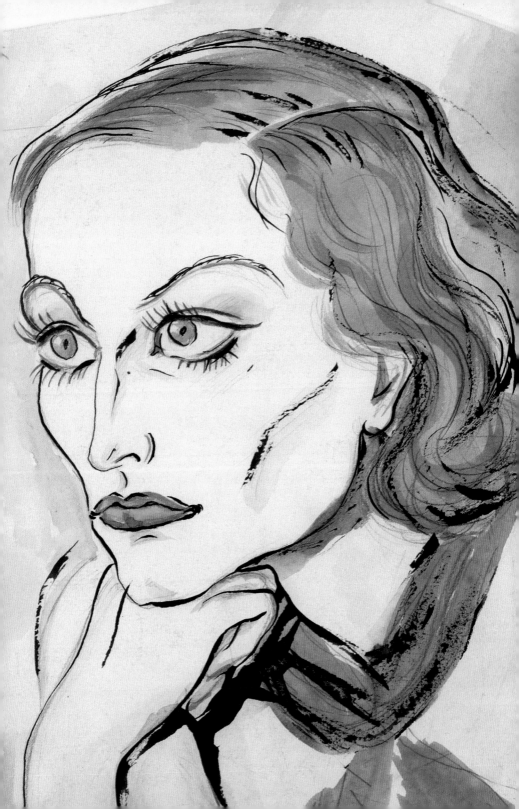

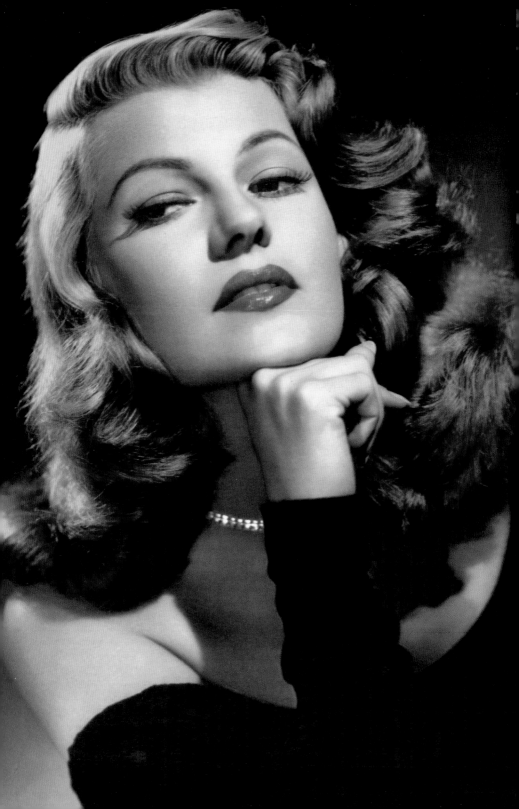

The relationship was clearly symbiotic: while red lipstick was fashionable during the era and worn on-screen to make the audience relate to the characters, its presence on the lips of Hollywood's great on-screen beauties enhanced the product's popularity and inspired women to buy it in droves. Of course, other lipstick color options were available, but red was the most popular shade by far. In the late 1930s, for example, the now-defunct brand Volupté released two new lipstick shades: a red called Hussy, to suggest seductive magnetism, and a demure soft pink called Lady. Hussy outsold Lady by well over 80 percent. In the mid-1940s, when Max Factor created print advertisements featuring glamorous images of Rita Hayworth for a new line of lipstick, three shades were included in the mix: clear red, blue red, and rose red.

While the popularity of red lipstick waned a bit in the 1960s and 1970s, because of an emphasis on a more natural look, it has always connoted confidence, elegance, and glamour in modern times. That's why it remains the cosmetic of choice for so many women: a simple rouge coating is synonymous with sophistication. That high level of refinement makes it especially beloved as a red-carpet accessory, as much by edgy tastemakers like Rihanna and Lady Gaga as by more classically dressed stars like Julianne Moore and Natalie Portman. Off duty, for mere mortals wearing it on a weekend with jeans, red lipstick makes the most casual outfit appear upscale and polished, and even an otherwise cosmetic-free face perfectly groomed.

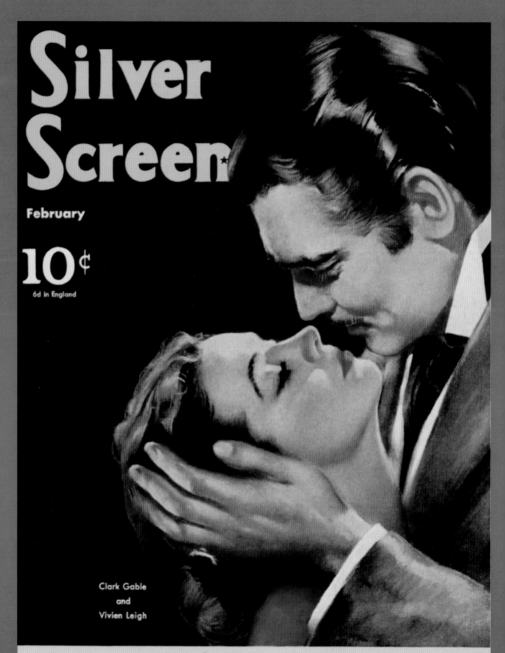

Silver Screen

February

10¢

6d in England

Clark Gable
and
Vivien Leigh

HOW TO BRING OUT THE CLARK GABLE IN ANY MAN!

His insistent mouth was parting her shaking lips, sending wild tremors along her nerves, evoking from her sensations she had never known she was capable of feeling. And before a swimming giddiness spun her round and round, she knew that she was kissing him back.

―MARGARET MITCHELL
Gone with the Wind (1936)

MY FAIR LADY

On a bad day, there's always lipstick.

—AUDREY HEPBURN

A STRIKING BEAUTY WHOSE distinctive and gamine sense of style has endured as an exemplar of elegance, the iconic Audrey Hepburn is lauded for her natural grace, poise, and unpretentious but always flawless cosmopolitan chic. With her delicate bone structure and dramatic coloring—dark brown hair and eyes, strong eyebrows, long neck, and alabaster skin— red lipstick highlighted her features beautifully. In fact, red lipstick was often the focal point of her look on-screen in key scenes from films like *Funny Face*, *Sabrina*, and *War and Peace*. Ironically, she wore a much quieter shade in her best-known film, *Breakfast at Tiffany's*—Revlon's Pink in the Afternoon, which is still available—but in that instance, red would have been overkill, juxtaposed with her character's oversized dark sunglasses and multistranded pearl necklace. Hepburn surely knew that.

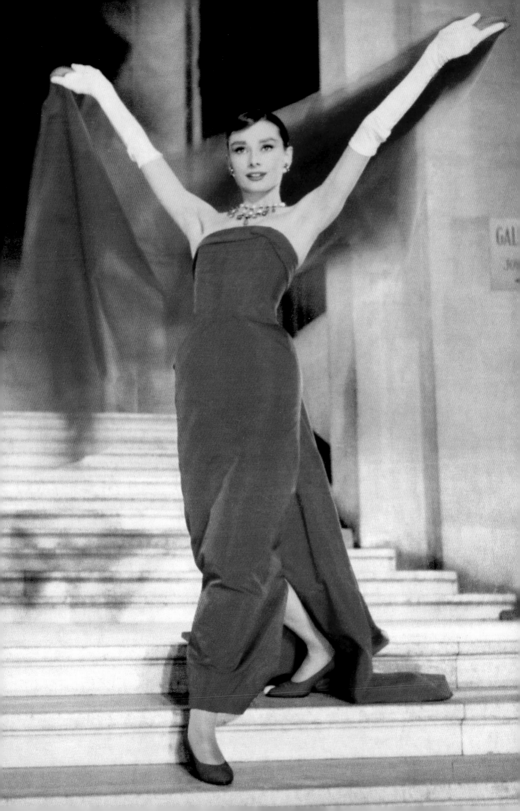

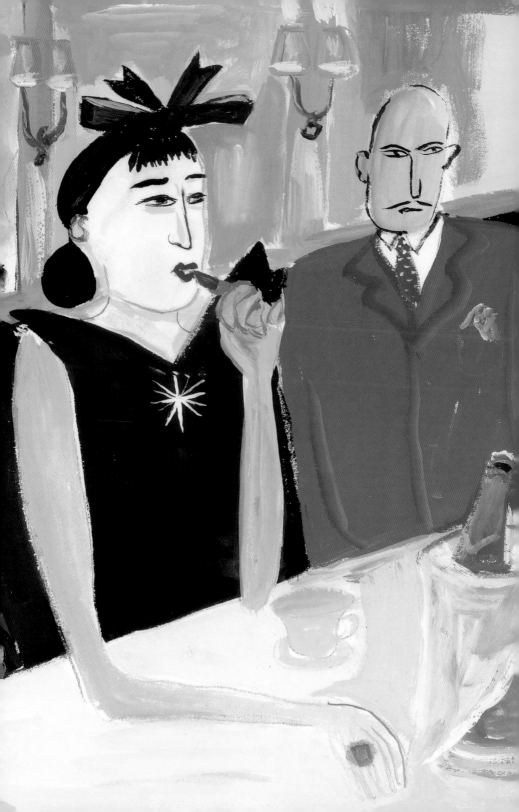

FRENCH KISS

Beauty begins the moment
you decide to be yourself.

—COCO CHANEL

GABRIELLE "COCO" CHANEL CAST HERSELF AS HER
eponymous brand's ambassador, regularly wearing its signature
tweed suits, accessorized with a camellia pinned to the lapel, along
with a quilted leather 2.55 bag. She customarily favored matte
cherry-red lipstick; with her dark hair and pale skin, it was a
particularly flattering look.

In 1924, a few years after the launch of Chanel No. 5, Chanel
introduced red lipstick in three different shades. The initial collec-
tion consisted of Clair (clear), Moyen (medium) and Foncé (dark),
offering a capsule wardrobe of lip color to suit a variety of skin
tones and occasions. This original line was immediately success-
ful, and it expanded gradually. By 1936, four more takes on the
color were added: Garnet, Ruby, Fuchsia, and Sunrise. In American
department stores, the price per tube was $1.50, the equivalent
of about $27 today. Currently there's a wide choice of reds in the
line, including Gabrielle, a rich garnet, and Coco, which suggests
the hue of Mademoiselle Chanel's beloved Coromandel furniture.

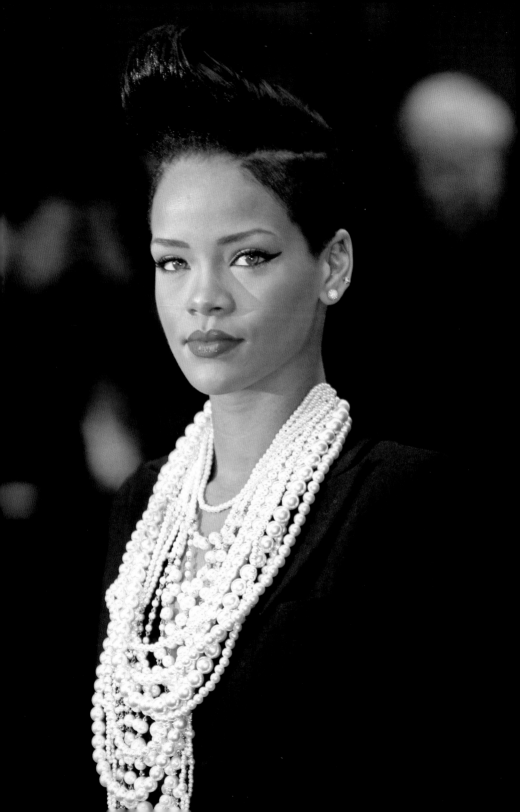

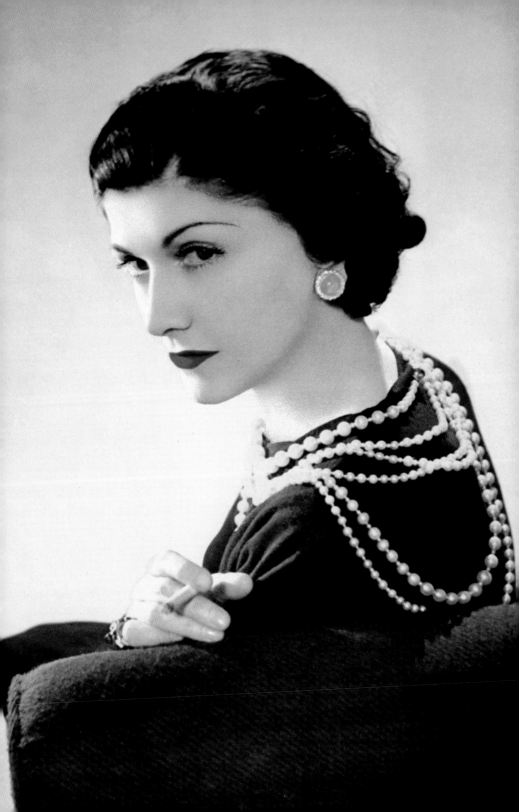

The most beautiful makeup on a woman is passion,

but cosmetics are easier to buy. —YVES SAINT LAURENT

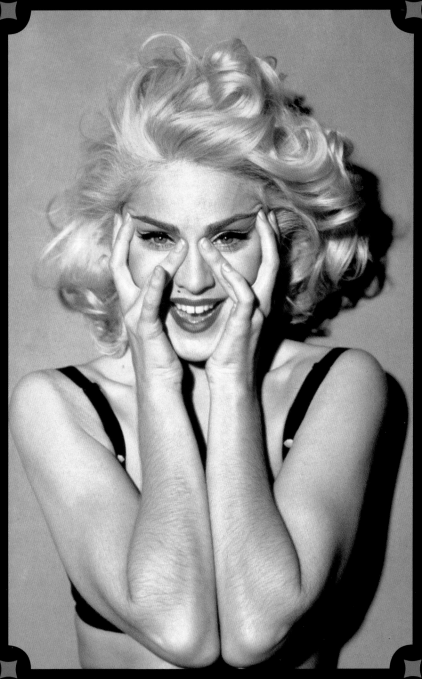

EXPRESS YOURSELF

Since her first album was released in 1983, Madonna's music has always worked hand in hand with the pop star's salient, sensual, and evolving image. Among her style trademarks—the black rubber bangles circa her "Holiday" single, the BOY TOY belt buckle of "Like A Virgin"—has frequently been matte red lipstick. As Madonna is an extremely vocal proponent of sexual and artistic freedom, red lipstick is a natural makeup choice, since it imparts sex appeal, glamour, daring, and self-assured rebelliousness.

One of Madonna's most impactful moments of wearing red lipstick was on the Blonde Ambition tour in 1990, when she was at the height of her fame. As part of her stage wear, which included a bra top with extra-pointy cone-shaped cups designed by Jean Paul Gaultier, Madonna wore a blue-red lipstick created for her by MAC's cofounder Frank Toskan. The shade's original name was Veruschka, after the German model Veruschka von Lehndorff, who's best known for her work in the 1960s, including a cameo in the film *Blow-Up*. Veruschka objected to the use of her name, so when MAC added the color to its commercial line, the company called it Russian Red.

When makeup trends moved beyond Russian Red's extremely matte finish, MAC renamed it Ruby Woo; Russian Red then became the moniker of a slightly deeper red that was creamier, less drying, and a bit less bright. Both colors are still bestsellers for the brand, which also offers a wide array of other popular reds, like orange-toned Lady Danger and rustier Chili.

The sudden streak of lipstick across the lips spells courage. . . . The streak of red steadies trembling lips. For one poignant moment, the little stick takes on the significance of the sword.

—"The Red Badge of Courage"
Harper's Bazaar, November 1937

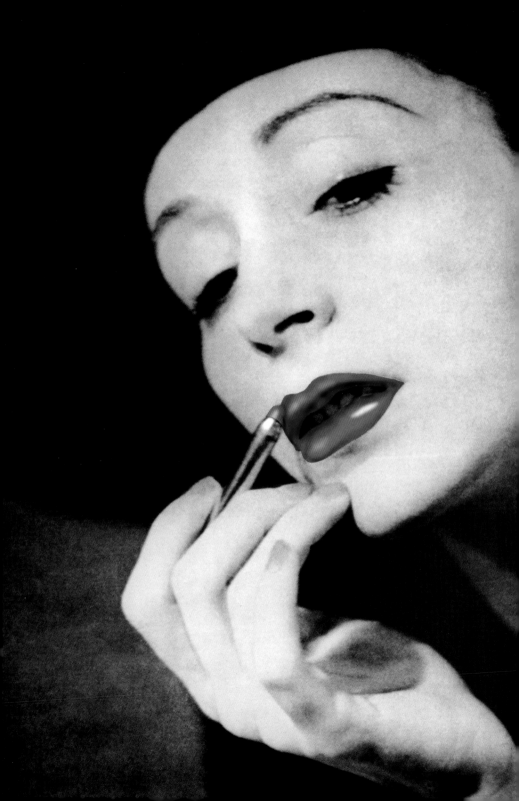

ROT-WEISS
MURATTI

ROT-WEISS

ROUGES A LÈVRES

GUERLAIN

Who's the
fairest of
them all?

FROM CLEOPATRA'S DRESSING TABLE TO YOURS

ANCIENT EGYPTIAN WOMEN REDDENED THEIR LIPS: proof exists on the lips of the famous bust of Nefertiti that resides in Berlin's Neues Museum and on the mummy case of Artemidora— a woman in her twenties who died between A.D. 90 and 100— found in Meir, Egypt, and now in the collection of the Metropolitan Museum of Art in New York City. Many historians believe the men in that civilization painted their lips red too.

Ancient Egypt's most famous queen, Cleopatra, also favored red lips. Her regal look included a red mouth and pronounced, thick black eyeliner, not unlike a contemporary cat eye, many centuries before that look became a popular beauty embellishment in the 1960s. While Cleopatra's subjects' colorants were made from ingredients like red ochre, a brownish shade found in natural pigments like clay, her lip color was created from a more expensive red dye: cochineal, which is made from crushed bugs. Yes, that sounds disgusting, but cochineal is still used today to color both food and makeup. To make a pound of Cleopatra's beloved lip stain required seventy thousand pests.

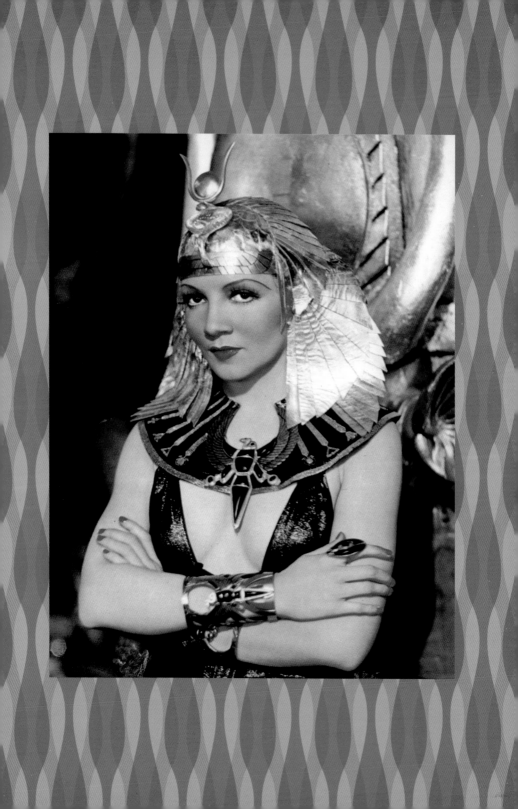

5e Année. — N° 213. ●● Le numéro : 50 centimes. 31 Juillet 1919.

LA BAÏONNETTE

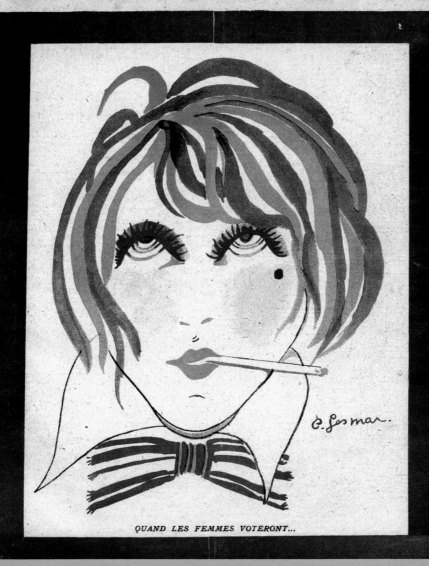

QUAND LES FEMMES VOTERONT...

SUFFRAGETTE RED

IN THE EARLY TWENTIETH CENTURY, SUFFRAGETTES in many countries were fighting for the right to vote. Their protests were revolutionary in an era when women were, for the most part, not yet active in politics or business and expected to remain at home fulfilling the roles of wife, homemaker, and mother. Wearing red lipstick—with its message of strength, confidence, boldness, and femininity—became another way for women to demonstrate their allegiance with the effort. It also represented a break with convention and, in many ways, a sea change in terms of the social attitudes toward and perception of women who wore it. For many generations prior, red lipstick had been associated with prostitutes, actresses, and showgirls.

Cosmetics entrepreneur Elizabeth Arden supported women's right to vote and strongly aligned herself with it. When the suffragettes staged a protest march past her salon in 1912, Arden and her team handed them red lipstick, not unlike marathon supporters who stand roadside, fortifying tired runners by offering them cups of water.

The following year, on March 3, 1913, when nearly five thousand women marched down Pennsylvania Avenue in Washington, DC, they wore red lipstick too. In fact, red lipstick was adopted as a part of the suffragette's de facto uniform elsewhere as well, such as England, where Emmeline Pankhurst, leader of the suffragette movement, and others devoted to the cause wore it regularly. Within a few years, wearing lipstick became commonplace, fueled in part by its use by the suffragettes, who kept on wearing it.

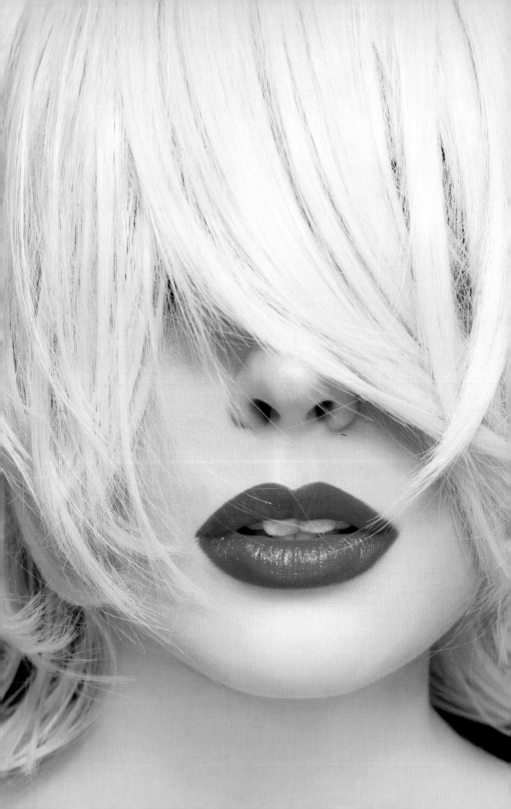

When in doubt, wear red.

═══════════

—BILL BLASS

THE NEW LOOK

AFTER WORLD WAR II, WOMEN'S FASHIONS BEGAN A
return to an emphatically feminine silhouette, propelled by the
debut of Christian Dior's influential 1947 New Look collection,
which featured fluid skirts, fitted jackets, and cinched waists. The
trademark color of the House of Dior was red: at the time, the
designer's shows—affairs that lasted about two hours and included
more than two hundred outfits—always included a selection of
vivid crimson dresses toward the middle of the lineup. These made
a standout statement that sharply contrasted a sea of ensembles
in the house's other prevalent shades of gray and black. Mr. Dior
fully understood the power and appeal of red, of which he once
said, "Red is a very energetic and beneficial color. It is the color
of life. I love red and I think it suits almost every complexion. It
is good for any time too. There is certainly a red for everyone." In
1949, the House of Dior created an exclusive lipstick that it gave
to its top 350 clients; that item became the precursor to Dior's
commercial cosmetics line, which still exists today. Although it's
logical to assume that the lipstick was red—the house's signature
and the most popular lip hue of the time—no tubes or documen-
tation of the exact shade still exist. A few years later, an official
makeup collection was unveiled on the designer's runway to a
broader audience with two shades of red lipstick, dubbed 9 and
99, worn by models wearing outfits to match. Today, the offering
still includes an elegant fire engine red called 999, its numerical
name an homage to those original iterations.

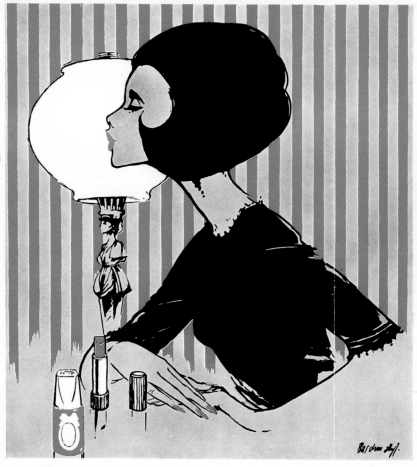

désormais chez Christian Dior
2 formules
de rouge à lèvres

$Dior$ et *ultra* $Dior$

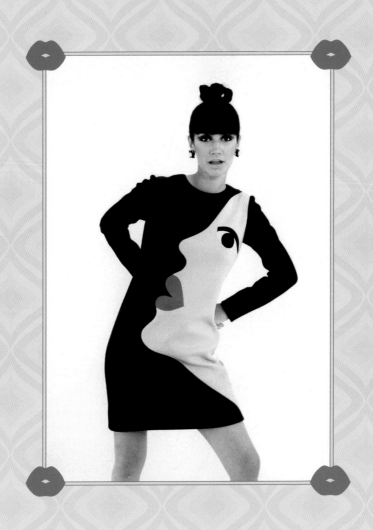

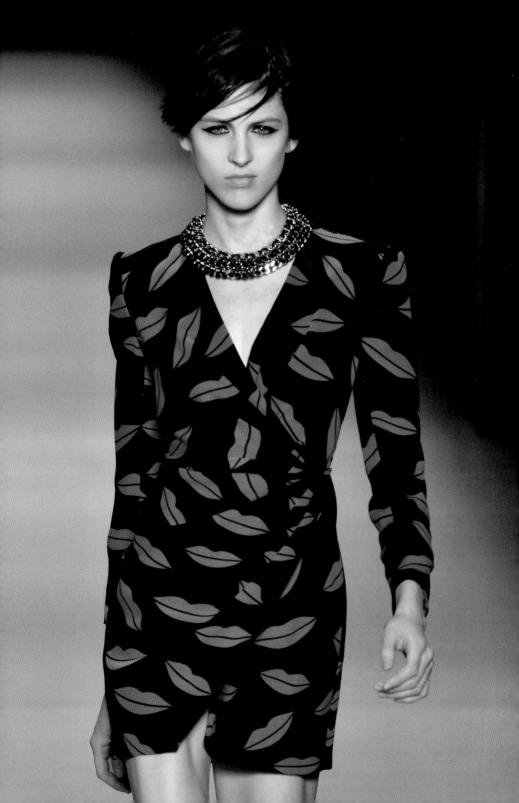

Make me immortal with a kiss.

—CHRISTOPHER MARLOWE
Doctor Faustus (c.1592)

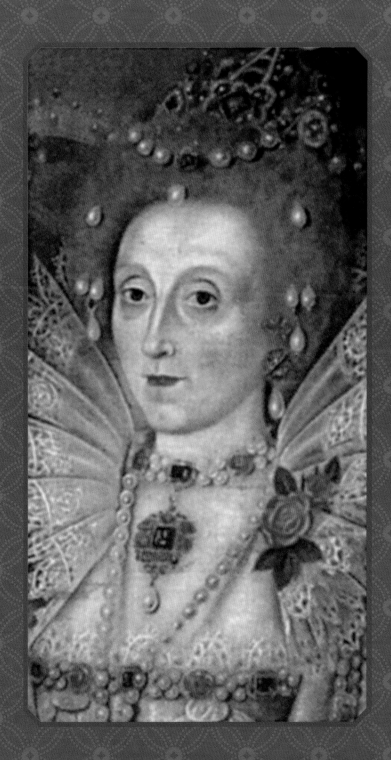

THE KISS OF DEATH

She is happy, for she knows that her dust is very pretty.

—DOROTHY PARKER
"Epitaph for a Darling Lady" (1925)

QUEEN ELIZABETH I, WHO RULED ENGLAND FROM 1558 to 1603, was obsessed with reddening her lips: she believed that the color warded off the devil and sinister spirits. Her tinting mixture consisted of cochineal, for its red color, combined with the binders gum arabic and egg white, along with sap from the inside of fig branches for slip.

Her makeup was distinctive—and potentially lethal as well: she wore black kohl eyeliner and achieved her alabaster skin through the abundant application of Venetian ceruse, a cosmetic of the day that was made by mixing white lead with vinegar and said to cause lead poisoning, skin damage, and hair loss. In paintings, the look created an image that seems, even centuries later, elevated and extreme. Although she lived a comparatively long life for the period—she was sixty-nine when she passed away—it's said that she died from blood poisoning. It's not unreasonable to assume that her decades of use of potentially toxic cosmetics, including the copious amount of lead that soaked into her skin from her beloved ceruse, contributed to her demise. When she died, a dense layer of lip color—some say from one-quarter to one-half inch thick—was caked on her mouth, the result of her wearing red relentlessly for so much of her life.

CORONATION RED

TWENTY-SEVEN-YEAR-OLD QUEEN ELIZABETH II slowly walked through Westminster Abbey for her coronation, on June 2, 1953. The world was watching, both literally and figuratively, for this day marked not only a major international event, but also the first of its kind to be broadcast globally. Those who had color television sets were treated to viewing the Queen in her royal finery: she was dressed in an elaborate floor-length silk gown, embroidered in lavish detail with a range of gems—including diamonds, opals, and amethysts, as well as pearls and crystals—created for her by acclaimed British designer Norman Hartnell, whose extensive work with the royal family earned him the lofty epithet "M.V.O., Dressmaker by Appointment to Her Majesty the Queen and Her Majesty Queen Elizabeth the Queen Mother."

As part of her ensemble for the day, the Queen commissioned a bespoke lipstick hue, a custom-mixed deep Bordeaux to coordinate with the Robe of State, a crimson velvet mantle edged with ermine and embroidered with gold lace and gold filigree. The shade was known as Balmoral, a nod to the Scottish castle where the royal family spends its holidays.

With an everyday palette of lipsticks that includes her tried-and-true red—although pinks have come to dominate as her color of choice as she has grown older—the Queen's love of lipstick is clear. Her favorite brands over the years have included Clarins and Elizabeth Arden, both of which have been granted coveted Royal Warrants of Appointment to acknowledge Her Majesty's use.

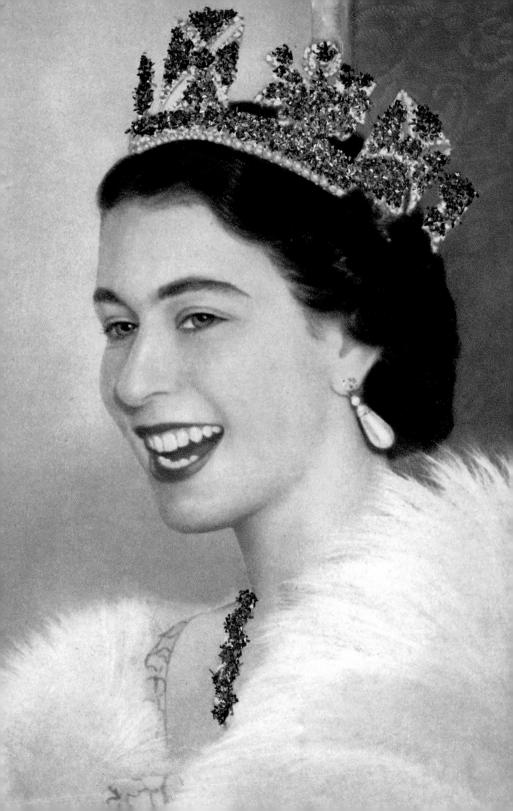

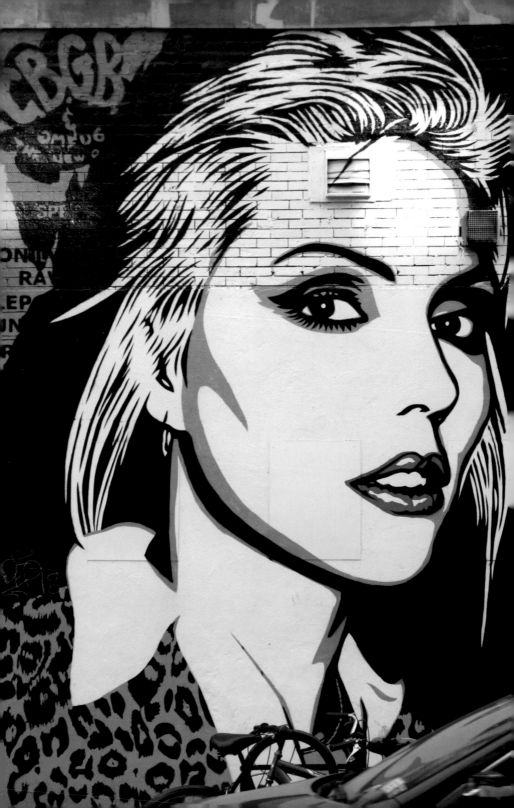

CHERRY BOMB

IN THE 1970S, PUNK ROCKERS TAPPED INTO RED LIP-
stick's shock value, forcing people to pay attention in an era in which
quiet nudes and pale pinks were the norm. A bright red mouth
coordinated perfectly with safety pins and ripped clothing and
spiked hair, offering a loud "listen up" and refusal to conform, even
for those who didn't choose to pick up a microphone. Debbie Harry
from Blondie wore it that way, as did Siouxsie Sioux and Exene
Cervenka (from the Los Angeles–based band X). Cherie Currie,
the lead singer of the Runaways—tauntingly yelped about being
a "ch-ch-ch-cherry bomb." Punks were looking for a reaction, and
red lips helped them get it.

The women of the grunge movement at the beginning of the
1990s, like Courtney Love of Hole and Kat Bjelland of Babes in
Toyland, also wore red lipstick as part of their posture of volume
and unconformity. Juxtaposed with baby doll dresses and bulky
Dr. Martens boots, the message was one of empowered femininity,
controlled by the women wearing those accessories as opposed to
society at large or mainstream trends.

Over the years, the looks of punk and grunge have gradually
entered the mainstream: motorcycle jackets are commonplace,
designers like Hedi Slimane have included expensive silk baby dolls
in runway collections, and red lipstick isn't necessarily applied
with an attitude of angry provocation. But the strong statement
red lipstick *does* make—its "look at me" intensity—enables many
wearers to tap into a little punk attitude every day.

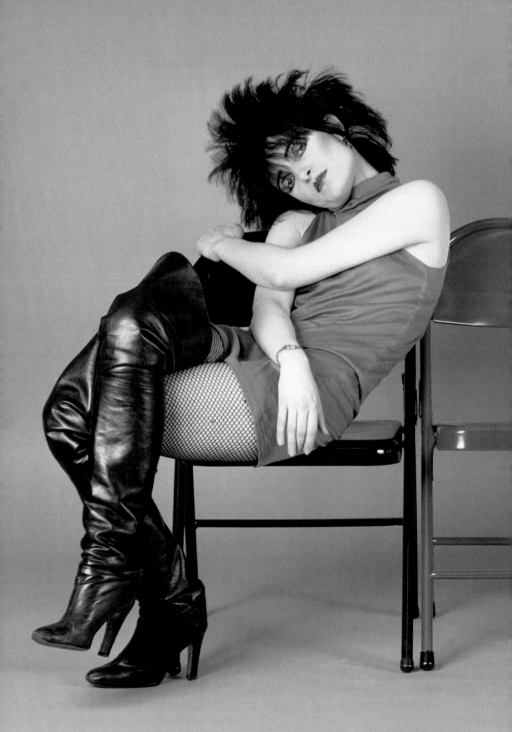

ROUGES A LÈVRES

VISON

ROSE AURORE

ROSE
MOUSSELINE

ROSE TENDRE

RADIEUX

ÉCLATANT

RUE CAMBON

GARANCE

SAUMON

MIDI

ÉTINCELANT

FLAMME

WHO'S AFRAID OF ELIZABETH TAYLOR?

AT THE PRIME OF HER CAREER IN THE 1950S, with films like *Giant*, *A Place in the Sun*, and *Suddenly, Last Summer* notched into her lipstick case, Elizabeth Taylor wore cherry-red lipstick as an essential, glamour-accentuating cosmetic. Her red mouth was part of an overall look that suggested an intense sensuality as well as undeniable beauty; when paired with the extravagant jewelry, fur stoles, and off-the-shoulder satin dresses she often favored, it also broadcast fame, success, and wealth. The lipstick color suited her so well; it contrasted perfectly with her double-lashed violet eyes, pale skin, and dark hair, and underlined her unattainable beauty. It was what she usually wore in her publicity photos at the time and when playing characters like Maggie Pollitt in *Cat on a Hot Tin Roof.*

As time went on, Taylor no longer wore red lipstick consistently, due in large part to the changing trend in the 1960s and 1970s toward more neutral lips. In films like 1963's *The V.I.P.s*, for example, she opted for creamy pink. Nonetheless, Taylor clearly understood the power of a crimson mouth. According to numerous biographies of the actress, legend has it that on the set of the 1983 television film *Between Friends*, extras were told to wear understated, nude-toned lipstick only, so as not to upstage Ms. Taylor. When a makeup artist put red lipstick on another actress, he was quickly scolded with the words "Nobody but Elizabeth wears red."

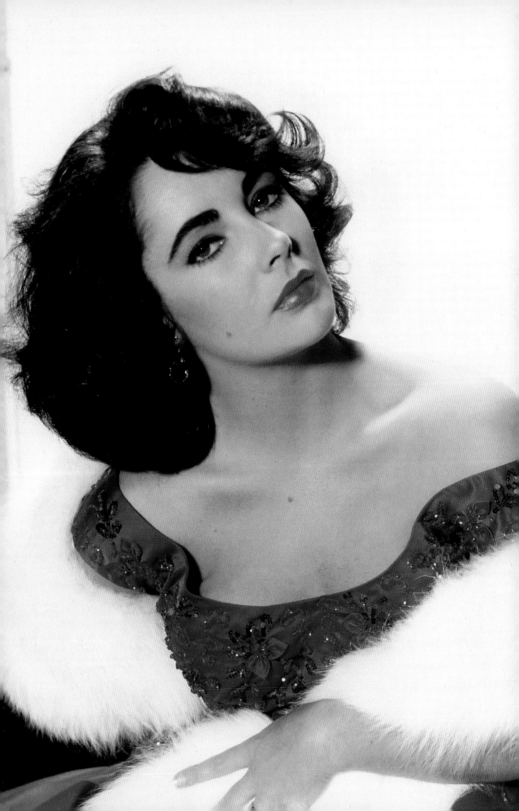

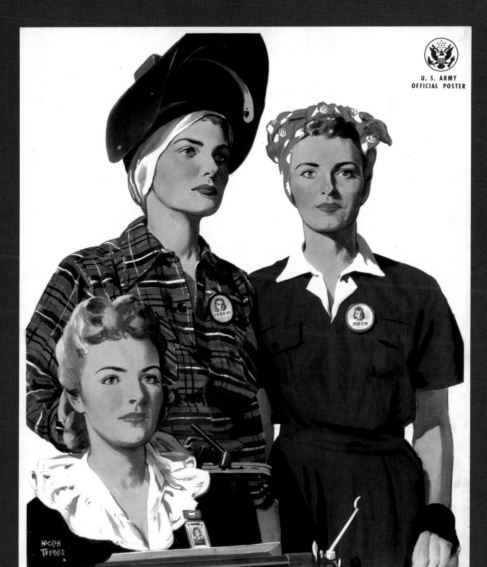

U. S. ARMY
OFFICIAL POSTER

SOLDIERS *without guns*

VICTORY RED

DURING WORLD WAR II, WOMEN IN ALLIED countries wore red lipstick as a sign of defiance—a symbol of their refusal to be worn down by the hardships and rationing that came with the conflict. Red lipstick came to represent resilience, bravery, camaraderie, and strength, underscored by the fact that many women took on jobs traditionally held by men who had gone to war. Feeling attractive was, admittedly, another motivator.

Adolf Hitler, incidentally, hated red lipstick. For him, the Aryan ideal was about a natural, unmade-up face and a healthy, unadulterated glow. Deliberate and noticeable red lipstick was, in his mind, too showy and sexy. A staunch vegetarian, he also objected to the animal fat that was a common ingredient in lip products at the time.

During the war, all sorts of essentials were rationed, including food, gas, and tin. Cosmetics, especially something as noticeable as colorful lipstick, however, were considered important to keeping up morale and self-esteem—and therefore too much of a necessity to ration. In England, Winston Churchill and the British government supported that point of view, never rationing lipstick, red or otherwise. As one official from the Ministry of Supply told British *Vogue* in 1942, "Cosmetics are as essential to a woman as a reasonable supply of tobacco is to a man."

Nonetheless, the product was highly taxed during the war, so it became a precious commodity. Some women daubed on beet juice for a more affordable fix of red instead. Although there was a war on, lipstick added a small touch of normalcy to daily life, offering uplifting, beautifying elements for women in Britain and beyond.

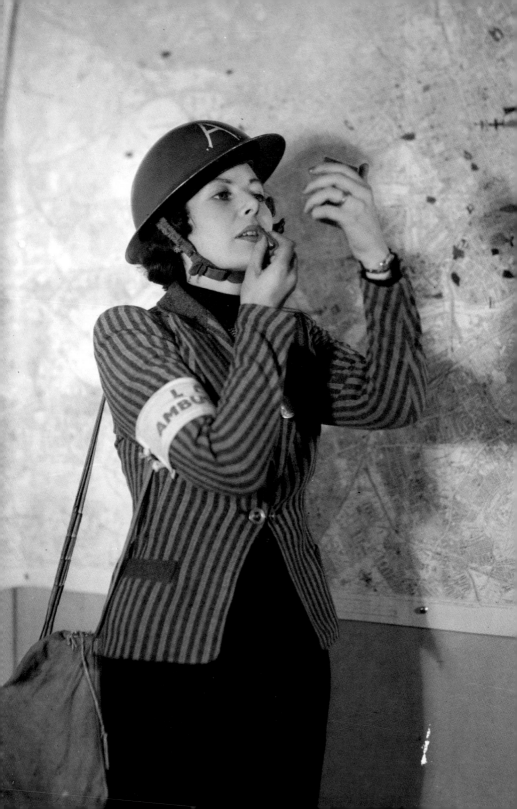

In America, lipstick tubes were made of plastic for a time, as metal was reserved for war use. In 1942, the U.S. War Production Board ordered makeup production to be dramatically decreased, but it was forced to reverse its ruling within a few months, when women spoke up in opposition.

During World War II, women joined the armed forces, serving in unprecedented ancillary roles to support men in combat. Makeup brands created products especially for these women as well as to capitalize on the prevalent patriotic fervor of the time. Red lipsticks of the day included Elizabeth Arden's Victory Red, which launched in 1941; Tussy's Fighting Red; and Helena Rubinstein's Regimental Red. The British brand Cyclax billed its iteration, Auxiliary Red, as "the lipstick for service women" in black-and-white advertisements in which the word "lipstick" was highlighted in bright crimson.

Elizabeth Arden was especially linked to the war effort: the brand was given the exclusive right to sell makeup on military bases. Arden was also recruited by the American government to create a shade of lipstick especially for the U.S. Marine Corps Women's Reserve, founded in 1943. As part of their uniform, these women were required to wear lipstick and nail polish that matched the red details of the organization's regulation work wear. Arden came up with a shade she dubbed Montezuma Red, in a nod to the Marine Corps hymn's promise to fight "from the halls of Montezuma" to way, way beyond. The following year, the lipstick was added to the Elizabeth Arden line and sold to consumers, accompanied by advertisements that were built around its military connection.

When the war ended, red lipstick became a means to lift women's spirits. On April 15, 1945, British troops liberated Bergen-Belsen, a concentration camp in north Germany. The scene was predictably grim. To help the women there regain a

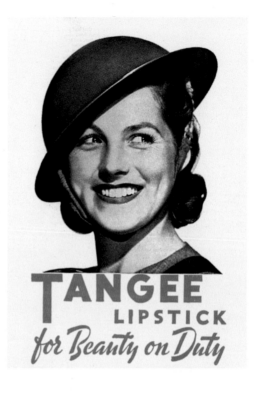

TANGEE
LIPSTICK
for Beauty on Duty

sense of normalcy and self-esteem, the British Red Cross sent in tubes of red lipstick. As superficial as sending in red lipstick might have seemed at first, the shipment was a vital emergency supply. As Lieutenant Colonel Mervyn Willett Gonin, one of the first officers who arrived there, wrote in his diary at the time, "Women lay in bed with no sheets and no nightie but with scarlet red lips, you saw them wandering about with nothing but a blanket over their shoulders, but with scarlet red lips. . . . At last someone had done something to make them individuals again; they were someone, no longer merely the number tattooed on the arm." Although red lipstick couldn't undo the horrors the women had endured, it was a powerful restorative that held promise of a new life.

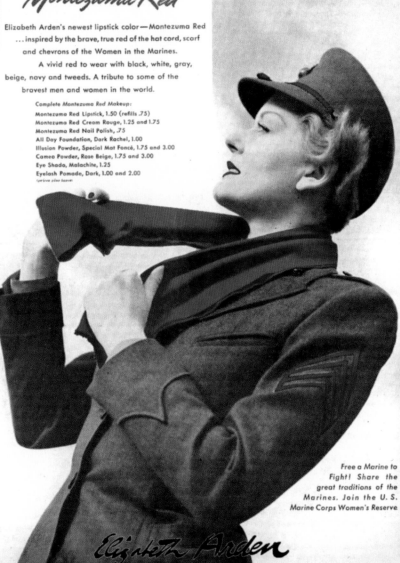

Montezuma Red

Elizabeth Arden's newest lipstick color — Montezuma Red
...inspired by the brave, true red of the hat cord, scarf
and chevrons of the Women in the Marines.

A vivid red to wear with black, white, gray,
beige, navy and tweeds. A tribute to some of the
bravest men and women in the world.

Complete Montezuma Red Makeup:
Montezuma Red Lipstick, 1.50 (refills .75)
Montezuma Red Cream Rouge, 1.25 and 1.75
Montezuma Red Nail Polish, .75
All Day Foundation, Dark Rachel, 1.00
Illusion Powder, Special Mat Foncé, 1.75 and 3.00
Cameo Powder, Rose Beige, 1.75 and 3.00
Eye Shado, Malachite, 1.25
Eyelash Pomade, Dark, 1.00 and 2.00
(prices plus taxes)

Free a Marine to
Fight! Share the
great traditions of the
Marines. Join the U.S.
Marine Corps Women's Reserve

Elizabeth Arden

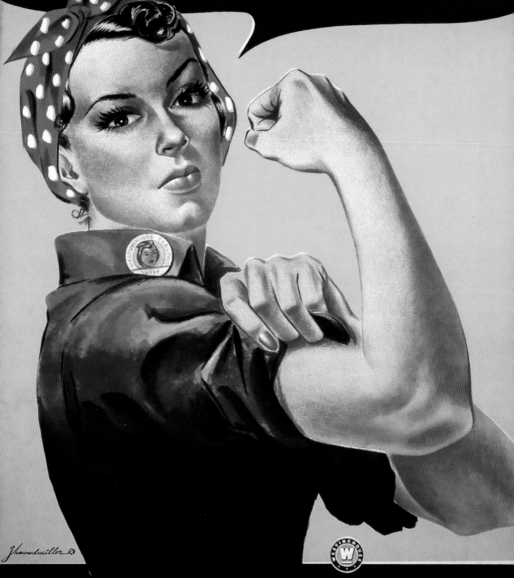

ROSIE THE RIVETER

DURING WORLD WAR II, WOMEN ENTERED THE workforce as they never had before, many taking factory jobs to fill spots left vacant by enlisted men, including making machinery, ammunition, and other metal tools and equipment for soldiers fighting overseas. In that era, the character of war worker Rosie the Riveter—clad in coveralls and heavy work shoes, wearing her hair tucked up into a red polka-dot bandanna with matching bright red lipstick—appeared in a few forms, including a wartime song and a Norman Rockwell painting that graced the cover of the *Saturday Evening Post* in 1943. But the most enduring Rosie appeared in a promotional poster to deter female employees from absenteeism produced by the Westinghouse Electric Corporation and hung in its factories. Under the words "We Can Do It!" was a colorful illustration of a focused, confident, and empowered working woman, flexing her biceps and gazing out with defiance and resolve. The image was modeled after a real woman, a former waitress and factory worker named Naomi Parker Fraley.

The poster was forgotten for four decades, according to Fraley's 2018 obituary in the *New York Times*; when it was eventually uncovered in the 1980s, probably in Washington's National Archives, it quickly came to represent female strength and resilience. Ever since, it's been in popular use in that context, with the face of another forceful woman, like former First Lady Michelle Obama, occasionally photoshopped in place of Fraley's determined stare.

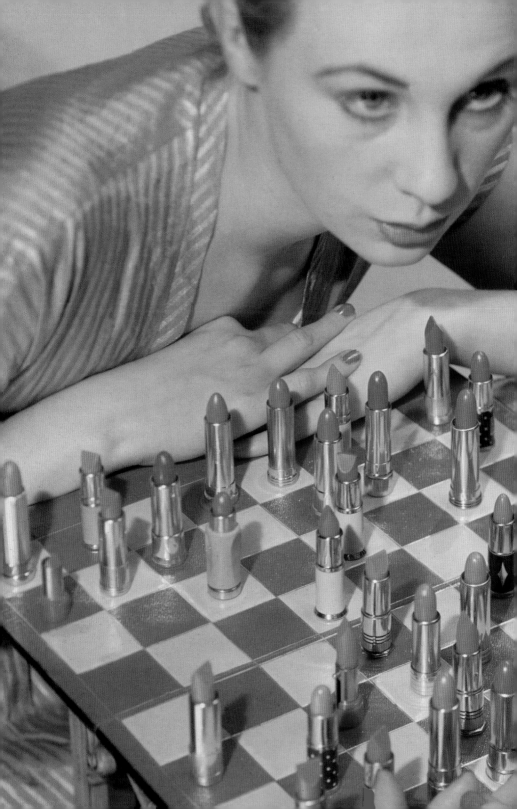

SEEING RED

WITHIN A FEW YEARS OF OPENING HER FIRST
salon in New York City in 1910, Elizabeth Arden (née Florence
Nightingale Graham), included color cosmetics in the mix of her
business's offerings. Helena Rubinstein—a personal fan of a strong
sanguine lip—started her company with a face cream in Australia
in 1902, opened a salon in New York City in 1915, and, like Arden,
expanded into makeup too. A rivalry was born.

For the next fifty years, many women in America and beyond
turned to either Arden or Rubinstein for their lipstick, and the two
entrepreneurs competed for their attention. Their products aimed
to reach the same demographic of female consumers, and they often
simultaneously embraced the same trends, like lipsticks that were
especially long-wearing and mascaras that were easy to apply.

The competition between the women seemed to go beyond just
aiming to be more successful in business: their tug-of-war clearly
appeared to be more personal than that, although they never actually
met. When, for example, Rubinstein decided to move her flagship
salon right near her rival's location in 1937, Arden promptly hired a
dozen of Rubinstein's top employees, including her brand's general
manager. Two years later, Rubinstein hired a replacement for that
top position: Arden's ex-husband, T. J. Lewis. For each woman, the
competition helped fuel her drive to succeed.

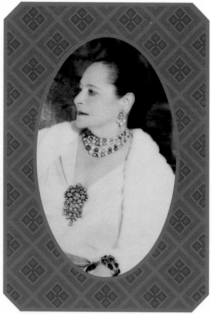

During an era in which women in high-ranking executive positions were extremely rare, cosmetics and skin care offered an ideal way for these industrious groundbreakers to capitalize on their decidedly feminine field of expertise—and, perhaps, claw their expertly manicured, colorful talons to the top. A few other driven women—like Madam C. J. Walker, who created a line of products with African American women in mind—also started cosmetics brands, but Arden and Rubinstein had an especially large impact. Today, Elizabeth Arden is still a major global cosmetics line; Helena Rubinstein's brand is still sold in Europe and online.

SEX APPEAL

MANY THEORETICIANS, BOTH SCIENTISTS AND cultural observers, have suggested that our reaction to red lips is involuntary. Some have asserted that they remind us of women's labia when they're engorged, aroused and ready for action. Others have brought up species that aren't all that far removed from humans, like baboons and chimpanzees, in which female genitalia redden and swell during periods of fertility. In addition, studies have proven that men find women wearing red lipstick more attractive than those wearing different colors on their lips or nothing at all. The overall thought is that red lips are a semiotic flag for sexual readiness.

The fact that we can choose when to send that signal simply by swooshing on a coating of lipstick is uniquely human. Or, as beauty entrepreneur Poppy King, the creator of three lipstick brands, puts it, "A woman wearing red lipstick is the closest that a woman can come to having an outward sign of arousal."

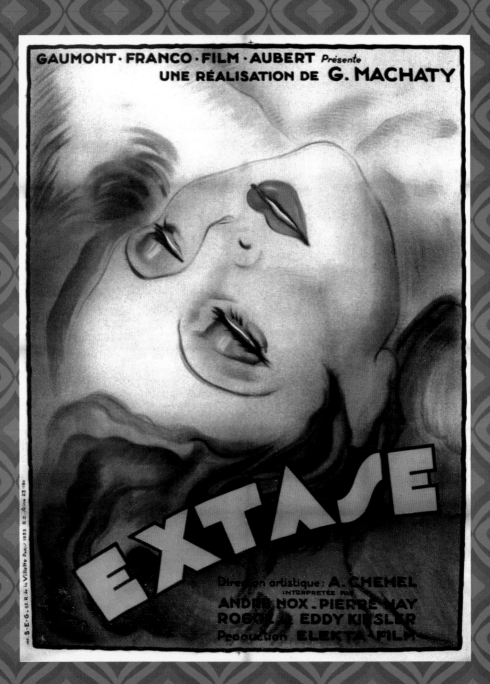

I forgot everything.
Your lips were so beautiful.

—F. SCOTT FITZGERALD
"Lipstick: A College Comedy" (1927)

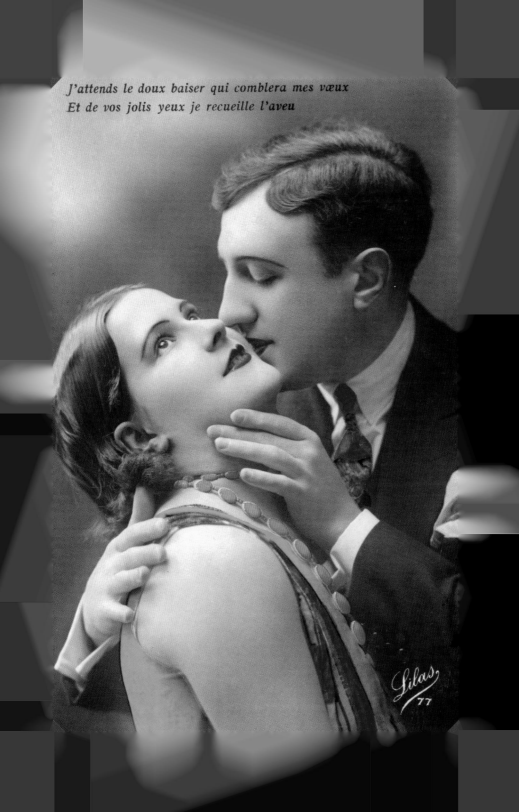

J'attends le doux baiser qui comblera mes vœux
Et de vos jolis yeux je recueille l'aveu

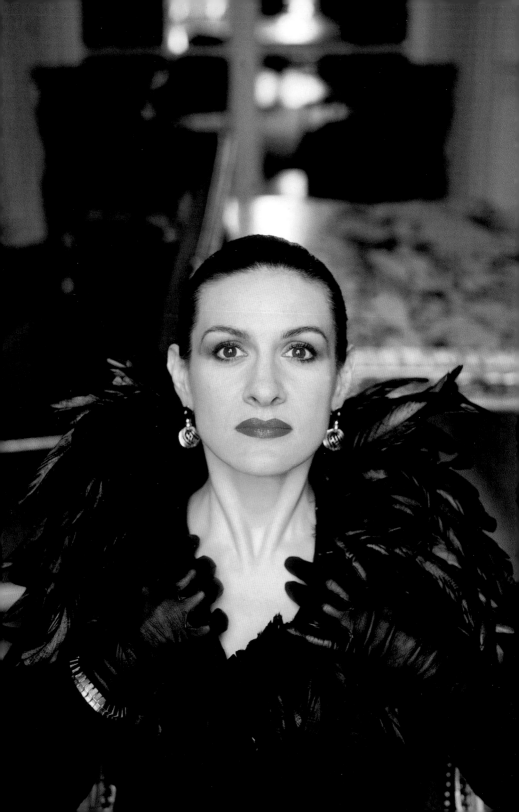

MON ROUGE

The daughter of the artist Pablo Picasso and Françoise Gilot, jewelry and accessories designer Paloma Picasso has been a muse to many influential artists who created portraits of her, including Andy Warhol, Helmut Newton, Richard Avedon, and her father. In the 1970s, the elegant, ultrachic Picasso was an "It Girl" associated with a glamorous circle of friends—Yves Saint Laurent, Loulou de la Falaise, Marisa Berenson, and Manolo Blahnik among them—who frequented international hot spots like Studio 54 and Le Palace.

Red lipstick was a big part of Picasso's public persona, and it sharply contrasted the pale, natural mouth that was in fashion at the time. The shade she always wore, a vivid blue red, projected great style, panache, and a fearless individuality. The color was extremely striking against her ebony hair and extremely pale skin; the overall look especially lent itself to Polaroid images—the selfie of the age—as it grabbed the dramatic flashes of red, white, and black.

Ironically, Picasso's love of red lipstick didn't come from self-confidence. "I was actually very shy," she admits. "For me, it was almost like using it as a shield to protect myself. You can kind of hide behind it and make a strong impression. I thought people would be scared away and not realize that I was more scared than they were."

But her red mouth became an identifiable uniform, so when the first perfume she created with L'Oréal, the eponymous Paloma, became a success after it was introduced in 1984, she followed up with a lipstick, a logical brand extension, a few years later. That product was called Mon Rouge: a true, intensely pigmented red with a satiny, long-lasting finish housed in decidedly luxurious packaging: a refined and hefty golden tube that felt more like a piece of precious jewelry than a makeup container.

The product's price was also high-end: a single tube cost about $30, or about $70 by today's standards. Although Mon Rouge was sold worldwide at upscale department stores like Harrods in London and Bloomingdale's in New York City, it was eventually discontinued. Nonetheless, the image of Picasso wearing the color in both portraits and her print advertisements remains as strong as ever, although these days she usually opts for a more neutral pink to make a softer fashion statement and to avoid getting recognized as frequently.

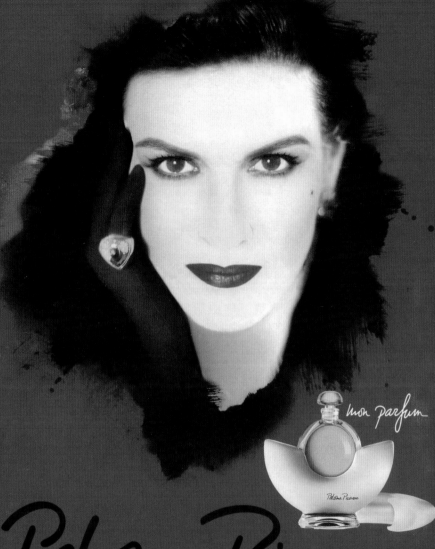

mon parfum

Paloma Picasso

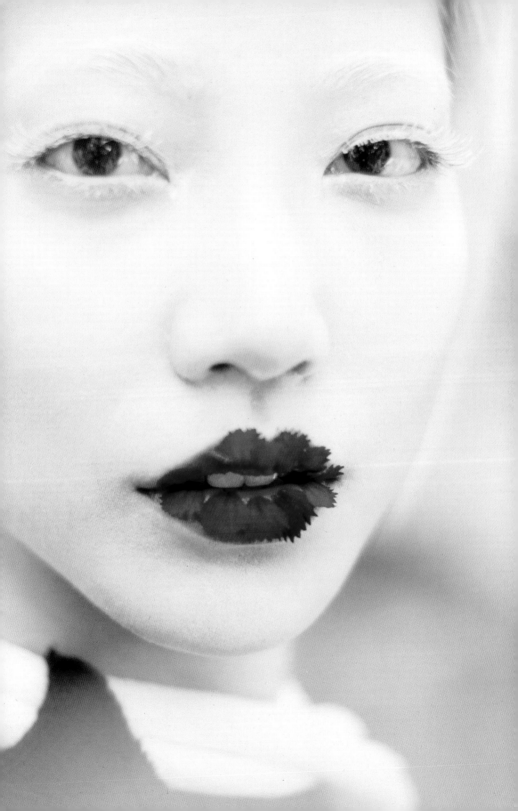

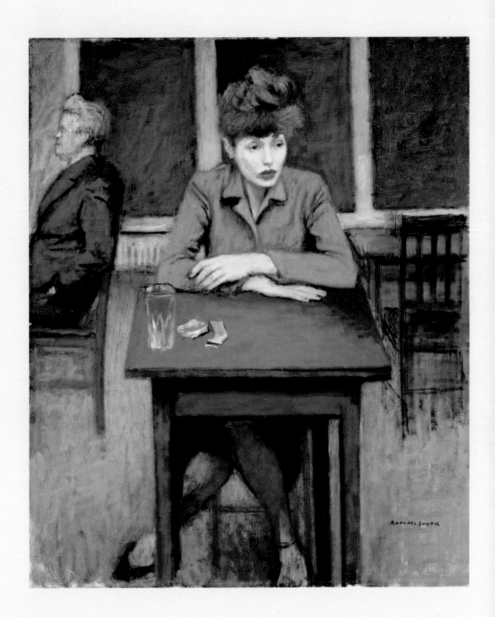

Oh My! Carnal Lady Danger

Lover Fame Seeker

Hot Magnetic Attraction Amazing

Desire Uninhibited Icon

Unzipped

Hot Rumor Dominant

Goddess

Dressed To Kill Wham!

Impassioned Hustler

Visionary

Kiss of
Fire

Warning

ne

Devil

Disorderly

Starwoman

Burning
Love

Eternal

Name Your Poison

Fire Alluring Flame

Obsessed! Original Sin

Siren

Regal

Love
Drunk

Bad Blood

Extreme

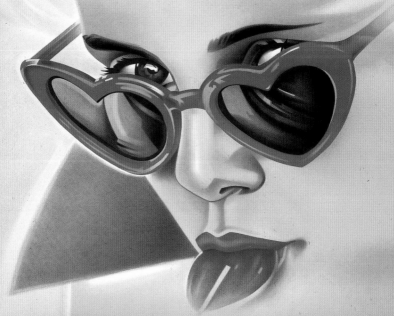

Comment a-t-on osé faire un film de LOLITA?

METRO-GOLDWYN-MAYER et SEVEN ARTS PRODUCTIONS présentent un film de JAMES B. HARRIS et STANLEY KUBRICK

LOLITA

avec JAMES MASON · SHELLEY WINTERS · PETER SELLERS et SUE LYON dans le rôle de "Lolita"

Réalisation de STANLEY KUBRICK Scénario de VLADIMIR NABOKOV d'après son roman "Lolita". Production de JAMES B. HARRIS

VISA MINISTERIEL N° 576

CINEMATO

WANTED, WANTED: Dolores Haze.
HAIR: brown. LIPS: scarlet.
AGE: five thousand three hundred days.
PROFESSION: none, or "starlet."

————————————————

—VLADIMIR NABOKOV
Lolita (1955)

SOME LIKE IT HOT

A CRIMSON MOUTH WAS AN ESSENTIAL COMPONENT of Marilyn Monroe's bombshell identity; her pursed, full lips and the soft, sulky voice that emerged from between them oozed sex appeal and a magnetic, ultra-womanly allure. Along with her platinum blond hair, red lipstick was the cosmetic equivalent of the slinky, low-cut dresses and high heels that were her sartorial trademark. But it was more than that: red lipstick served to enhance many of the characters she played. In roles like Lorelei Lee in *Gentlemen Prefer Blondes* and Chérie in *Bus Stop*, red lipstick was the ideal accessory to underscore her characters' femininity and seductiveness.

The application of red onto Monroe's lips on film sets was methodical and strategic: her makeup artist, Allan "Whitey" Snyder, used several shades of the color at a time, with a darker iteration near the edges of the lips and lighter versions toward the center to create an intensely accentuated pout. But the actress's seductive persona wasn't limited to just her movie roles: even off duty, a staple of her look was a liberal application of her favorite shade, Max Factor's Ruby Red. Although that brand is no longer available in America, it's still popular in Europe, where four wearable versions of red were introduced in 2016 as the Marilyn Monroe Lipstick Collection. One of the options is her beloved Ruby Red.

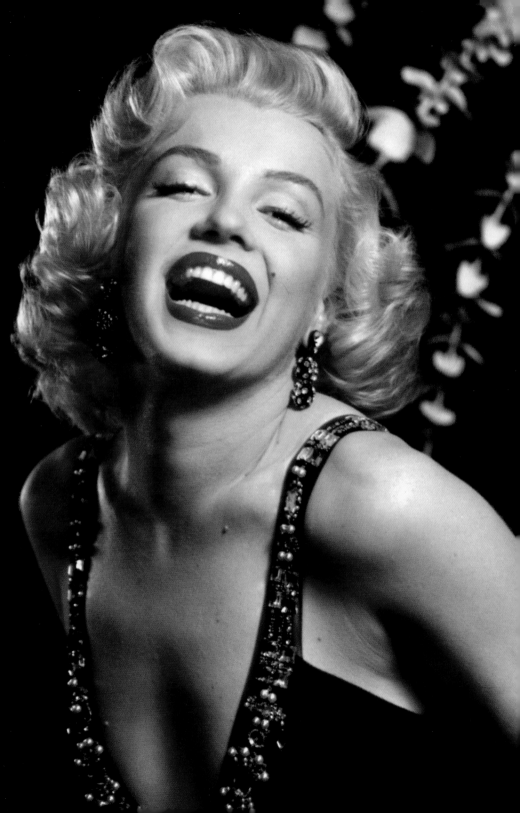

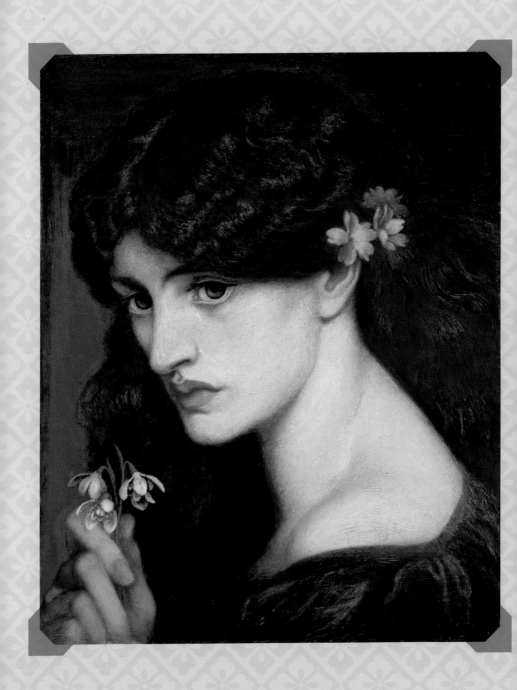

SUFFERING FOR BEAUTY

PEOPLE HAVE BEEN DAUBING THEIR LIPS WITH RED for the last five thousand years; frequently, ancient formulas unknowingly included caustic ingredients, so women (and men too, in some cultures) were literally suffering—and were even ultimately poisoned or disfigured, or both—in their effort to look beautiful. Lead was commonly used in lip coloring: around 2500 B.C., for example, the queen of the southern Mesopotamian city of Ur, Pu-abi, smeared her lips with a mixture of lead and crushed ochre, a type of clay. Although her death wasn't specifically blamed on her lip color, she did pass away young, in her forties.

The ancient Egyptians also used red ochre to give their lips an earthy red tint, like the rusty shade you'd find on a piece of terra-cotta pottery. Their lip colorants included other problematic ingredients: fucus-algin, a plant dye that is high in mercury; iodine; and bromine mannite, also plant-based and potentially lethal. The Egyptians used some harmless but unusual ingredients too; they sometimes added fish scales to impart pearlescence, essentially creating the world's first shimmer lipsticks.

Vermilion—the pigment that also describes its rich orangey-red hue—was used across many civilizations in lip color for centuries. In ancient China a few thousand years ago, the pigment, also known as mercuric sulfide, was mixed with blood from various animals along with animal fat, which gave the product an unctuous, spreadable texture. Fast-forward to nineteenth-century Europe: vermilion was still a common component of lip coloring. It is, unfortunately, laden with mercury, the potentially toxic mineral that can lead to myriad health problems. Although the dangers of mercury were uncovered around that time, the hazards of ingesting it have been on scientists' radar only for the last fifty years or so.

Today, lead and mercury are long gone from lipstick formulations, and with a greater understanding of the risks of specific ingredients, lipsticks are safer than they've ever been. Nonetheless, some formulas still include things women might well not want to ingest, including plastics like polyethylene as well as propylene glycol, a type of alcohol. And ingest we do: an average woman today will inadvertently consume between four and nine pounds of lipstick in her lifetime. And some key tried-and-true ingredients remain: cochineal, the colorant that was Cleopatra's favorite, is usually called carmine these days and is still a common part of red lipstick (and, yes, still made from ground cochineals). Modern lipsticks, however, often include beneficial ingredients too, like moisturizing vitamin E and avocado oil.

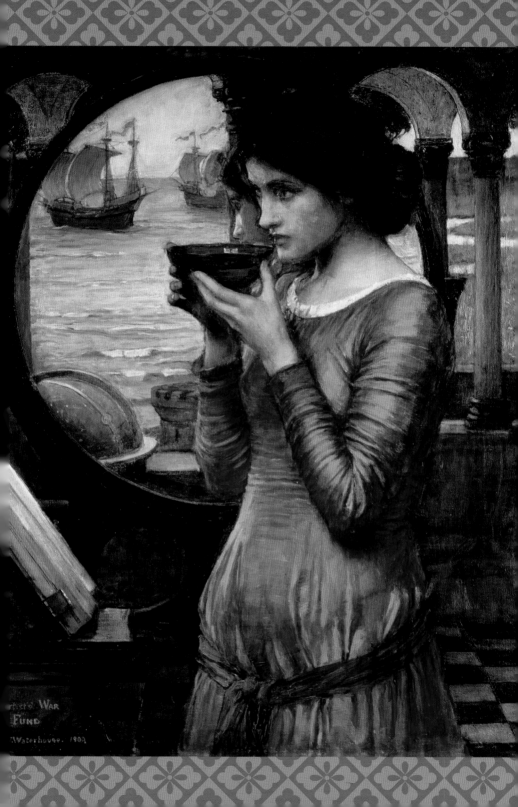

J.Waterhouse. 1900

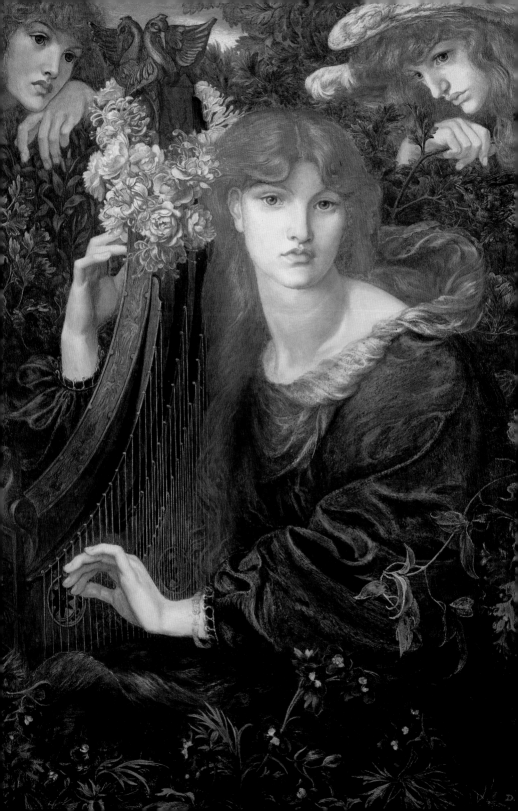

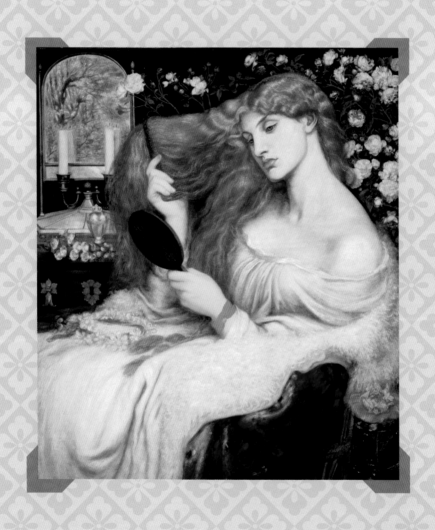

WHY DON'T YOU . . . WEAR RED?

I can't imagine becoming bored with red—
it would be like becoming bored
with the person you love.

—DIANA VREELAND

D.V. (1984)

DIANA VREELAND, FASHION VISIONARY AND EDITOR
in chief of *Vogue* from 1963 through 1971, adored the color red.
Her passion for the shade mirrored her overall exuberance. Red
seemed to express her most outstanding qualities: dynamism, con-
fidence, the fearless love of making a statement, and an emphatic
alliance with beautiful things. The color was omnipresent, from
the knee-high Roger Vivier snakeskin boots she wore frequently
to the floor-to-ceiling decor of the living room in her apartment,
which was covered in red paint and textured cerise brocade and
filled with scarlet-hued bric-a-brac.

Red was part of Vreeland's makeup look, especially on her lips.
She loved deep red nails too; one color she used for her manicures
was custom blended by Charles Revson, the founder of Revlon, to
match a bottle she'd brought home to New York City from Paris.
Bright red blush was the maquillage's finishing touch. For her, red
was simply the most perfect color in the rainbow. As she put it, "Red
is the great clarifier—bright, cleansing, and revealing. It makes all
other colors beautiful."

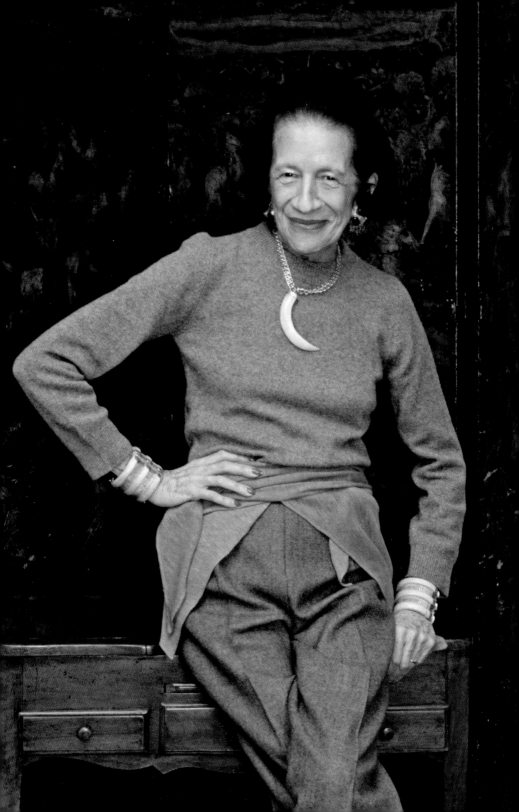

CUPID'S BOW

THE END OF WORLD WAR I BROUGHT WITH IT A major cultural shift for Western women. The long skirts and corsetry that had been customary for centuries fell out of fashion, finally giving way to the shorter, loose-fitting chemise first introduced by Paul Poiret in 1910—and the birth of the flapper. Flappers personified this newfound sense of freedom in look and attitude. They wore shorter dresses, bobbed their hair, and listened to jazz. They danced, smoked cigarettes, and drank alcohol in public too. Actresses such as Clara Bow and Louise Brooks popularized the look and attitude on-screen and off. Bow, the original "It Girl," starred as a hard-partying jazz baby in numerous films, as did Brooks, whose bob inspired women worldwide to cut their hair into a sharp, sassy crop.

The most essential flapper makeup item was red lipstick, used as a counterpoint to pale, powdered skin. Frequently, the lips were outlined with an especially pointy angle at the top, which visually compressed the mouth's perimeter and accentuated flappers' flirty sensuality and free-spirited strength. Known as a Cupid's bow, the look dominated in the 1920s, so much so that Helena Rubinstein produced a lipstick also named Cupid's Bow, which promised to deliver the perfect, and perfectly pointy, shape every time.

Although the stock market crash in 1929 brought an end to the decade-long party, the flappers' beloved red lipstick left an indelible mark. From that point on, wearing noticeable lipstick in public was not only widely accepted but a standard part of women's daily grooming rituals through the 1950s.

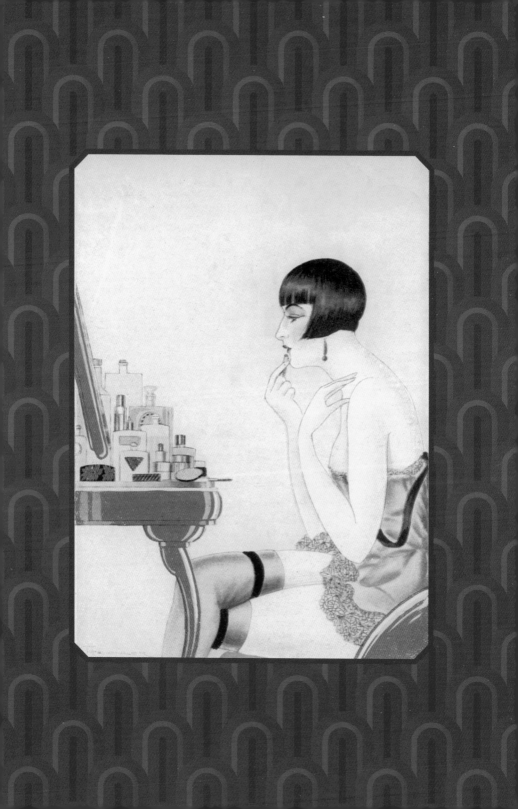

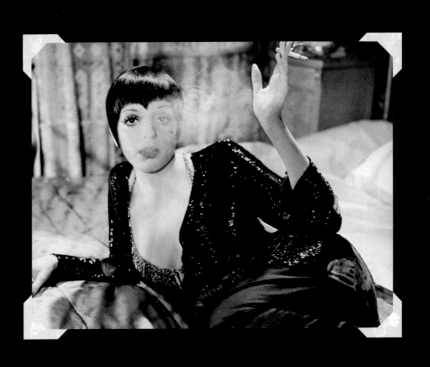

SLIPPERY WHEN WET

THE FASHIONS OF THE 1980S LEANED TOWARD excess, exemplified by thick and boxy shoulder pads, brashly colored dresses, teased-up hair, and heavy makeup. Noticeable contouring blush was the norm, as were thick, inky black lines around the eyes and, frequently, a striking and shiny red lip. The actress Joan Collins in the role of Alexis Carrington on *Dynasty* embodied the look and its hyperbolic, over-the-top details.

In hindsight, the overall look seems exaggerated and excessive, but it exuded nerve and feminine fortitude. In Robert Palmer's 1985 "Addicted to Love" music video, five stunning yet aloof women played "the band." Each dressed in a close-fitting little black dress, accessorized with high heels, tightly pulled back hair, and lips that were slathered in a hyper-slick red, they were powerful, polished, and seductive, in spite of their deliberately blasé expressions. Although the women were presented as the backing band, they were clearly the stars. A look was born, and it was emulated worldwide, thanks to the impact of music videos at the time.

Then there was the sultry-voiced Sade, whose velvety songs, like "Your Love is King" and "Smooth Operator," were the soundtrack of romantic moments for many during the era. Sade's seductive music was underlined by her beauty look: dark hair pulled back, almond-shaped eyes lined in a 1960s'-inspired cat-eye with a bit of mascara and neutral eyeshadow, and—almost always—her luscious lips accentuated with red lipstick.

As the 1980s progressed, intensely colored lipsticks remained popular, but matte and demi-matte finishes replaced the slick finish of a

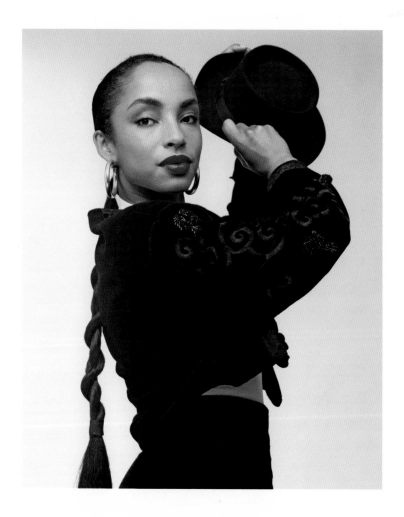

gloss. A minimalist look was returning to fashion too, with pouf skirts giving way to slip dresses that paired more logically with understated makeup. Women were rising higher than ever before in business and government positions, and while red lipstick communicated focus and strength, many ambitious executives and aspiring leaders felt a less shiny lipstick conveyed greater authority. Decades later, the preference toward lip color with a flatter finish still remains among many businesswomen.

Kiss me, and you will see how important I am.

—SYLVIA PLATH
Diary entry
February 19, 1956

LIPSTICK WARS

By the 1940s and 1950s, lipstick had become big business. Cosmetics brands competed fiercely to dominate the category. Elizabeth Arden and Helen Rubinstein were well-known frontrunners, as was Revlon, which promoted coordinating nail polish and lipstick. That brand's best-known matched shade is arguably Fire & Ice, for which the company created elegant magazine advertisements that featured model Dorian Leigh in a gorgeous dress paired with a list of provocative questions, like "Do you close your eyes when you're kissed?" Shot by Richard Avedon, the campaign promised women a certain sophistication and mystique that went well beyond the attainably priced product.

Another cosmetics entrepreneur of the era, Hazel Bishop, added to the competition. A Barnard College graduate, she had studied chemistry; by experimenting with formulas she created a lipstick that promised to be nondrying and kiss-proof, and she founded a company to produce and release it in 1950. Of the product's initial six colors, five were red, including shades like Red Red Red and Medium Red. Bishop also came up with several iterations

of her invention, including No-Smear Lipstick and Longer-Lasting Lipstick. Her lipsticks were a huge success, propelled by advertisements on a medium that many makeup brands, like Helena Rubinstein and Elizabeth Arden, dismissed as being too unrefined for cosmetics: television.

Admittedly, the brand's television ads weren't particularly sophisticated, but they were persuasive. In one noteworthy Hazel Bishop ad on the popular show *Beat the Clock*, for example, a model applied two different deeply pigmented lipsticks to her palm—one from Bishop and one from an unnamed brand—and wiped them off aggressively. Bishop's lipstick stayed on while the other vanished. While segments like this felt like hype—closer to an infomercial than a live version of Revlon's glamorous magazine advertisements—their message came across clearly.

Charles Revson, Revlon's founder, observed the success of Bishop's television ads and quickly followed suit: in the mid-1950s, Revlon became a brand sponsor of the popular weekly game show *The $64,000 Question*. The company placed its logos on set, and there was a hard-sell tone to its ads, which touted Revlon as "the greatest name in cosmetics," but they worked, helping to propel Revlon to become a leader in the cosmetics category. The show's audience was enormous, and it was highly rated in an era when television was a main source of family entertainment.

This period of hypercompetitive entrepreneurs—Revson, Bishop, Rubinstein, and Arden—became known as the "Lipstick Wars," with each vying desperately to outsell the other. Although the cosmetics business is still fiercely competitive, the intensity of that period was unprecedented and hasn't been matched since.

PURE 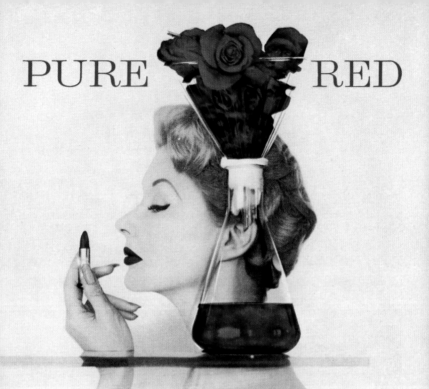 RED

Imagine the vibrant heart of a red rose,
distilled through purest light rays and you have
Elizabeth Arden's pristine Pure Red—a colour
of radiant brightness for every woman's lips.
For this, remember, is that rarest of reds, Pure Red
—wonderful with the leafy greens of Spring,
brilliant forecast for fashion's choice. Wear Pure
Red creamy Lipstick with pure Red Cream
Rouge and exquisite Elizabeth Arden
Powder harmonised to your complexion

Elizabeth Arden

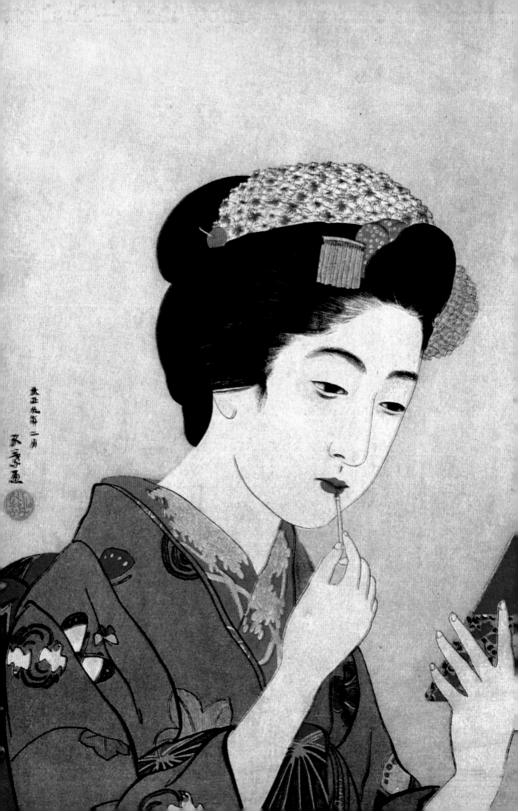

THE GEISHA:
A STUDY IN RED LIPS

TRADITIONAL AND UNCOMPROMISING, THE MAKEUP
of the geisha includes an especially heightened take on red lipstick,
pairing vivid matte crimson lips with a highly whitened complex-
ion. While rouged accents abound throughout the look—outlining
the eyes, accentuating eyebrows, and daubed on the very sensuous
nape—the focus falls firmly on those profoundly pigmented lips.
Like a Kabuki actor, the geisha works within a grand historical and
theatrical framework. A Kabuki actor also intensifies his lips, eye-
brows, and other parts of his face in charismatic crimson.

Historically, the lip coloring that a geisha uses is derived
from the benibana flower, a type of safflower that's indigenous to
Japan. The bulk of each flower's petals are yellow—the bud looks

a bit like a tiny, condensed sunflower—but some are a deep crimson. For thousands of years, those rarer red corollas have been fermented to be made into lip pigment, typically referred to as *komachi* (beautiful girl), *beni* (red), or simply *beni* for short. The carmine color is impregnated into the lining of a small enameled bowl—it looks a bit like an *ochoko*, a small Japanese teacup—taking on a chartreuse hue. To apply the color, the geisha touches a tiny brush dampened with water to the glossy green interior; the brush turns red on contact. The color starts out quite sheer but can be built into the thick, impermeable coat that's become one of the geisha's trademarks.

A geisha's lips are never fully covered in red. In her first year as a *maiko*, or geisha-in-training, only the lower lip gets painted. But even when the trainee becomes a full-fledged geisha, only a portion of the upper and lower lips is covered, delineating a lip line that's exaggerated and unrealistic, like a cartoon. Today, many geishas add a final step to the lip application process by dipping a small brush into the slightly molten interior of a small piece of hard candy, using the fluid, sugary center as a sealant. An ever-so-slightly glazed finish is left on the lips; it softens the matte texture and ensures that the intense lip color stays on for many hours.

JAPAN

sans hésiter

le rouge baiser

M. Ph. F. 47　　　　　　　　　　CALCULÉ A PARIS PAR PAUL BAUDECROUX

MAGASIN D'EXPOSITION : 27, FAUBOURG SAINT-HONORÉ · PARIS-8ᵉ

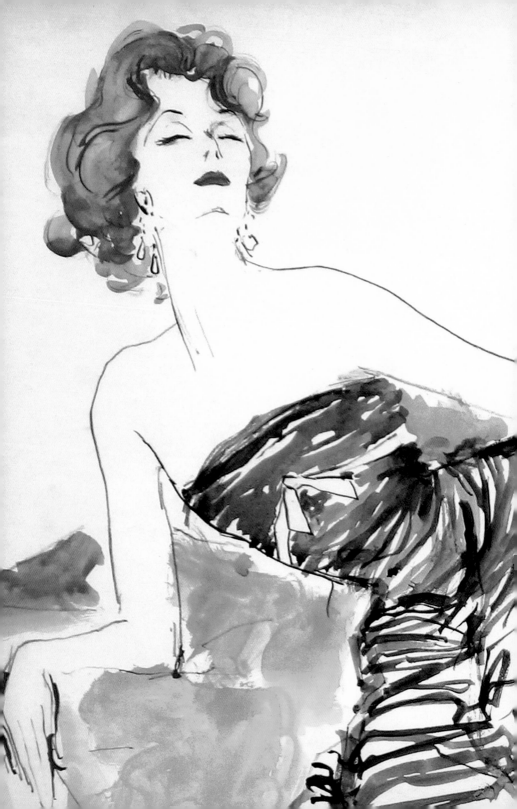

A woman's first job is to choose
the right shade of lipstick.

—CAROLE LOMBARD

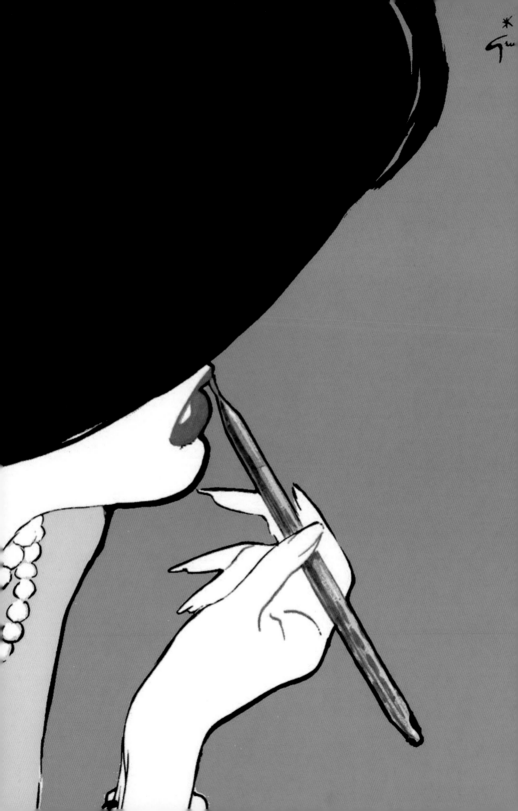

PULLING IT OFF

DESPITE ITS WIDESPREAD APPEAL, RED LIPSTICK can be polarizing. The strong statement it makes and the precise application it requires can be intimidating.

When Bobbi Brown crafted the newspaper advertisement that introduced her eponymous cosmetics line in 1991 at Bergdorf Goodman, she came up with a resonant tagline: "You're either a red lipstick person or you're not." But really, there's a red for everyone, contingent on finding the best fit in terms of two components: texture and shade.

FINISH

Although it is most frequently associated with an extra-assertive punch of intensity, red lipstick can easily be worn to softer effect. The difference lies in the texture: a tinted lip balm with a hint of scarlet added to its emollient formula makes a more muted and, arguably, more wearable impression than a lipstick with a supersaturated, long-lasting flat finish. It's the difference between listening to a low-key acoustic performance of a classic song and a hard rock take on the same track. In other words, the identical hue will have a distinct impact, depending on the texture.

MATTE · In its most intense lipstick formulation—a flat matte finish—red lipstick is dressy, strong, and polished. It's a texture for executives and celebrities on red carpets: more than any other genre of lip product, it projects a high sense of style, self-assurance, and a certain inaccessibility. Matte is especially

suited to red—it's a clean and modern look, with color and texture working in tandem. Matte lipstick takes a bit more care and time to apply than, say, a wash of red lip gloss—lip liner and a lip brush can help with getting it on perfectly, neither beyond the natural contours of the mouth or too far inside them, with just the right degree of pointiness and curve.

Matte is also the most long-lasting formulation of lipstick, thanks to its high concentration of pigment versus creamier ingredients. The high pigment level can make a matte lipstick drying, although a quick swipe of lip balm before applying can help make it less so. And—wearer beware!—matte typically requires reapplication throughout the day to maintain its potent coverage, especially after eating and drinking.

CREAM • Easy to wear and softly feminine, a cream or satin finish is the workhorse of lipstick finishes. Polished, noticeable but not extreme, this finish is appropriate for just about any occasion, from weekend to work to weddings. It looks great on women of all ages as well.

Cream and satin finishes are also more comfortable to wear than matte options, since emollient ingredients are typically included in their formulas. But the emollience gives them a greater tendency to smear, bleed, and fade than flatter lipsticks too. A lip pencil comes in handy to reduce those issues, either in a matching shade of red or a nude tone. Another trick makeup artists use is the addition of a thin layer of foundation under the lip color to help it adhere. Still, with a cream or satin lipstick, be prepared to reapply throughout the day.

GLOSS • The shiny look of lip gloss makes it the sexiest category of lip finish. The wetness has an aura of seduction, suggesting licked lips or, perhaps, ones that are damp from being kissed. Formulas range from slightly glistening to full-on liquid-y, with words like "lacquer," "vinyl," or "shine" sometimes added to the names of products to describe their slick coating.

In red, gloss can resemble a fabulously unctuous cherry syrup. Some options are a bit gummy, while others are light and easy to put on and forget about afterward. Admittedly, some can get messy and bleed. Finding one that's an ideal mix of slide, fluid finish, and cling can be challenging, but there are many, many options on the market.

Lip gloss is particularly easy to apply—usually with a wand and, in many cases, without the aid of a mirror—so it's especially well suited for off-duty wear. Its aqueous feel makes it decidedly not long-lasting, so most fans carry a tube with them for touch-ups throughout the day or evening.

STAIN • Deep, natural, and arguably the easiest way to wear red on the lips, stains can appear less "done" than other lip formulas but still deliver a forceful dose of color. They're applied without fuss or tools like lip liner; some can be a bit drying, so require a bit of counteracting lip balm after a day's wear. There's an effortless feel and look to stains: in red, they make your lips look like you've just eaten a bowl of raspberry sorbet or a handful of extremely ripe cherries. And that is exactly what makes them perfect for casual wear. Also, they're simple to apply, even with one's fingers, and most tend to stay on for a very long time.

TONE

"Red" is really an umbrella term for a huge range of deeply nuanced hues, from pinkish watermelon to orangey geranium to fire engine red to oxblood. There truly is a rainbow within the color family, with ample options to suit literally everyone. Although there are some general rules most women follow, finding the perfect shade can take some trial and error, plus ample time at the makeup counter. In addition to one's coloring, it's worth keeping in mind what clothing you'll be wearing it with, where you'll be going, and even the season and climate.

BLUE RED • Clear, clean blue red—the most timeless crimson hue—suits a wide range of skin tones, from extra fair to very dark; it works as well on platinum blondes as women whose hair is jet black. It's especially flattering on cool skin tones—complexions with a bit of pink or blue to their hue—and it makes green or blue eyes particularly sparkle. It's best paired with makeup that's similarly classic, like black eyeliner; eye makeup and blush that are too statement-y can feel like overkill. It can make teeth look whiter—the blue counteracts yellow—but it can also accentuate blushing, broken capillaries, and rosacea.

ORANGE RED • Red lipstick shades with orange or yellow in their mix, like coral and vermilion, perfectly suit warm skin tones, like tan, olive, or yellow. They make a strong statement on women with very fair skin but can still look great on them, especially if there's a hint of saffron undertone to their complexion. Orange reds are bright and wearable, lively and optimistic, but can emphasize dark circles or hyperpigmentation. They complement all eye colors too. And they feel summery, so are extremely suitable for wearing in warmer weather and climates and with lighter,

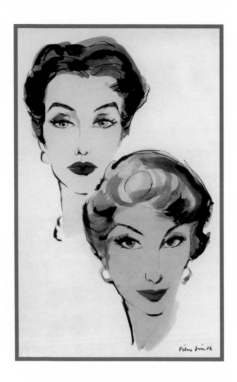

breezier clothing. A vivid shade from this family of tones makes quite a potent impact, so orange reds are best worn without too much other makeup to let the shade take the spotlight.

DEEP RED • The hues in this category of red have names that evoke heady glasses of wine and winter tweeds: claret, oxblood, maroon, and burgundy. They're best paired with dark eyes and deep skin tones for a look that's especially striking and elegant, but they can potentially overpower light complexions or women with fair eyes, veering a bit into Goth territory. Keeping the rest of one's makeup a bit understated helps balance their intensity. Deep red lipsticks can be just right for an evening look. Overall, though, colors of this intensity and depth look more at home in cooler months and climates and when worn with heavier clothing to provide a visual balance.

FORM AND FORMULA

THE BASIC INGREDIENTS USED TO FORMULATE lipstick have been the same for centuries: a mixture of oil, pigment, and some sort of wax to give it substance. Technology has improved the recipe over the years, but that's still the essential blend, with some pleasing additions like fragrance, flavor, and, sometimes, conditioners. Formulas have become less drying but can still last on the lips a very long time; smoothing polymers provide textures that glide instead of stickily stall as you wipe them on; coating on color pigments can give a more velvety finish after the product has been applied. Animal-derived products like lanolin that were once mainstays in lip color are now not as commonly used, as most brands these days don't test on animals as they once did.

The precursor to modern lipsticks was invented around the end of the first century by a doctor, Abu al-Qasim, also known as Albucasis. He created molds into which sticks of solid perfume could be shaped, making it easy to carry around and apply—as lipstick would become many centuries later—and without the mess of a liquid or a salve. Albucasis was best known for writing a medical textbook, *Al-Tasrif*, which was used by doctors for centuries—but this early invention has, arguably, had more lasting appeal.

Lipstick wasn't available in stick form until the late 1800s. Lip makeup came in a small glass tub filled with colored cream or as a tinted balm or salve. These tiny jars were better suited to a dressing table than a handbag. Guerlain changed that in 1884 with the introduction of Ne M'Oubliez Pas, the first makeup product that can validly be described as lipstick. Ne M'Oubliez Pas's packaging

was still quite different from what you'd find at a makeup counter today: it came in a squat tube made of a thin curved sheet of tin and stood, cap on, at about an inch and a half high. The formula was different too; the lipstick was made from a blend of beeswax, oil, and dark grapes.

The most commonplace modern lipstick, with its swivel-up mechanism at the bottom, was created in 1922 by Nashville-based

inventor James Bruce Mason Jr. In many ways, Mason's lipstick was an update of a creation from about a decade earlier: the push-up lipstick case, which was introduced in 1915 by a cosmetics importer named Maurice Levy, who packed dense matte lipstick into a narrow, bullet-shaped nickel cylinder with a little lever on the side.

"Bullet" is, in fact, the most exact word for it, for the shape was inspired in part by World War I ammunition shells. Both Mason's and Levy's iterations were often smaller than what's used today. Chanel's first lipstick, introduced in 1924, for example, was 1.77 inches high and less than a half inch in diameter, about half the height and 25 percent thinner than today's tubes. Still, these tubes had the key benefits of today's iterations: portability, ease of use, and affordability. And the timing of their invention came just as the general population was embracing red lipstick as an acceptable cosmetic after a period in which it was associated with prostitution or as an act of rebellion.

These days, what we all call lipstick often, strictly speaking, isn't: lip color comes in sticks that resemble nubby children's crayons, artists' skinny drawing pencils, or Magic Markers. There are pots filled with lip tints that deliver various degrees of color, shine, and balmy moisture and wands with squishy, porous applications to deliver red-hued gloss or extra-matte liquid lipstick. And true lipsticks don't necessarily come in a barrel-shaped tube either; the dimensions can be long and thin, or especially squat, or, really, anything between. Whatever the format, the ultimate appeal remains the same: the payoff of striking color inside each covetable package.

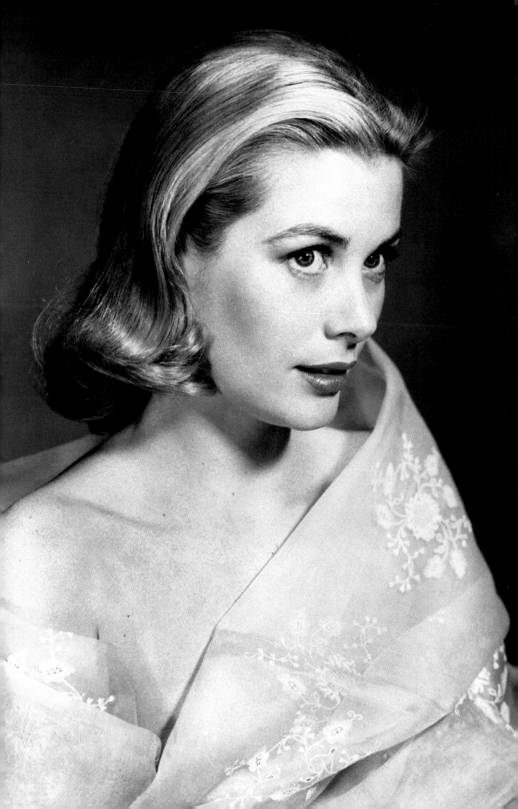

DIAL R FOR REGAL

GRACE KELLY EXUDED A COOL GLAMOUR. Her sophisticated beauty seemed effortless; softly waved blond hair, polished and never overtly sexy clothing, and, frequently, a slick of red lipstick were the key components of her look. On her, red somehow seemed like a neutral, natural color: the ultimate expression of femininity and commanding elegance. There was an almost regal quality to her look, which made her 1956 marriage to Monaco's Prince Rainier III seem almost preternatural. A favorite of Alfred Hitchcock, who had a well-documented penchant for aloof blondes, Kelly brought her stately demeanor to her film roles too. In *Dial M for Murder* (1954), her first film with the director, she played Margot Wendice; in the film's memorable opening scene, she appears in a lace-detailed scarlet dress with lipstick to match. As Lisa Carol Fremont in *Rear Window* (1954), she was dressed and made up impeccably, wearing red lipstick in most of the film's scenes—even while her character is breezily reading through an issue of *Harper's Bazaar*, she's wearing perfectly applied candy apple–red lipstick with a coordinating shirt. Through Hitchcock's lens, and ultimately ours, Kelly epitomized an enviably sleek and decidedly inaccessible feminine ideal.

Forty years later, in the mid-1990s, Kelly's remote beauty was echoed by Carolyn Bessette, a striking young woman who dated and ultimately married someone who might well be described as American royalty: John F. Kennedy Jr. Their relationship made her a major paparazzi target, yet she exhibited a natural grace and stately poise that felt reminiscent of Kelly's, even when she and Kennedy were regularly followed on the streets of New York City by intrusive photographers. Bessette Kennedy was a lover of red lipstick too, rotating between a few different shades, including MAC's Ruby Woo. At their wedding, she wore another one of her favorites, Bobbi Brown's Ruby Stain, an easy-to-wear pomegranate-like color with a finish that looked like a traditional lipstick blotted several times. Although the original Ruby Stain no longer exists, its look is not hard to emulate by applying a deep red lipstick and then tamping it down with a tissue or towel to leave just a remnant of flat, saturated color on the lips.

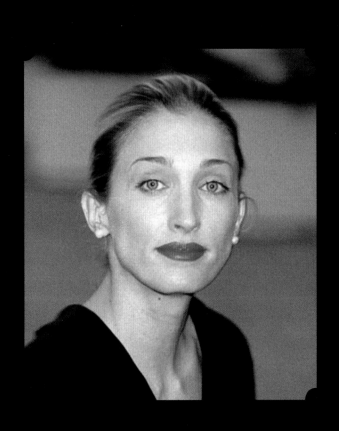

l'accent sur l'e
du
mot
beauté

Rouges à lèvres
de
GUERLAIN

J CHARNOTET

Rouge à Lèvres
AUTOMATIQUE

Guerlain

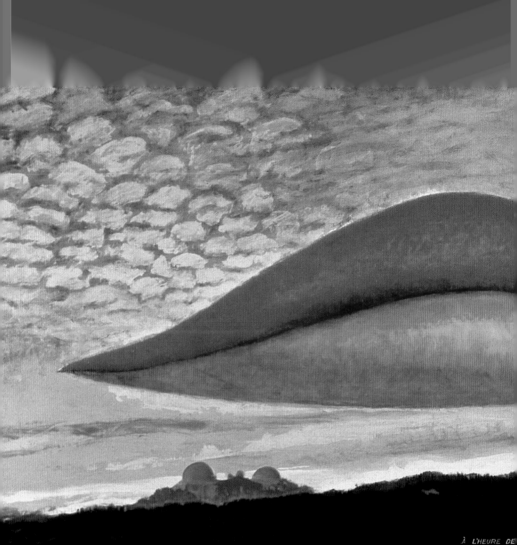

À L'HEURE DE

LES AMOUREUX

<small>RED LIPS INCITE TEMPTATION, AFFECTION, AND</small>
lust. They're a symbol of all those lascivious things and have been

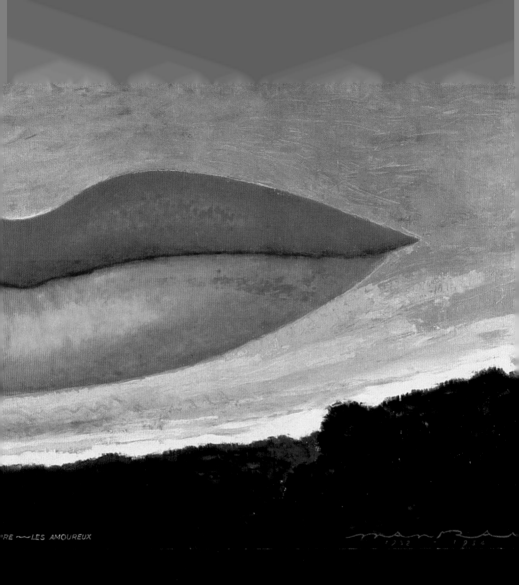

RE ～LES AMOUREUX

examples is Man Ray's *A l'Heure de l'Observatoire: Les Amoureux* (*Observatory Time: The Lovers*). Man Ray painted the image when his lover Lee Miller left him in 1932, after just three intense years together. The image took two years to complete and represented the artist's sense of longing, loss, and desire and the seductive, if

The kiss itself is immortal.
It travels from lip to lip,
century to century,
from age to age.

—GUY DE MAUPASSANT
"One Phase of Love" (1884)

ACKNOWLEDGMENTS

MY LOVE AFFAIR WITH RED LIPSTICK BEGAN AS A teenager and has grown exponentially over many years of devotion. I'm so grateful to my wonderful editor, Elizabeth Viscott Sullivan, for sharing that deep passion and for her insight, advice, support, and unending enthusiasm. Deep gratitude to Bil Donovan for creating such a gorgeous jacket. And many thanks to art director Lynne Yeamans and designer Raphael Geroni for the stunning book design, as well as production director Susan Kosko, Dani Segelbaum, and the entire Harper Design team for their support.

I'm grateful too, as always, to Richard Grabel for help and encouragement.

Many thanks go to the experts, executives, and makeup artists who made time to be interviewed for the book and the photographers and artists (and their estates and galleries) whose work appears inside. To those who went beyond the call of duty in this regard, an extra-special thank you: Jennifer Balbier, Frederic Bourdelier, Amanda Carolan, John Demsey, Julie Deydier, Patrick Doucet, Ryan Dziadul, Thomas Haggerty and Mai Pham at Bridgeman Images, Marcia Kilgore, Kim Lachman, Bridget O'Neill, Kate Babb Shone, Kiva Silberfeld, Troy Surratt, Kevin Tachman, Jason Waterworth, and Marki Zabar.

Thanks also to Nancy Carlson, Katherine Ensslen, Poppy King, Henrietta Lovell, Joan Snitzer, and Shelley von Strunckel.

This book would not have been possible without two beloved Felders: Raoul and Millie. To them, I offer admiration and a red-lipsticked kiss.

SELECT BIBLIOGRAPHY

Books

Ackerman, Diane. *A Natural History of the Senses.* New York: Vintage, 1991.

Cohen, Meg, and Karen Kozlowski. *Read My Lips: A Cultural History of Lipstick.* San Francisco, CA: Chronicle Books, 1998.

Corson, Richard. *Fashions in Makeup from Ancient to Modern Times.* London: Peter Owen, 2003.

Downing, Sarah Jane. *Beauty and Cosmetics 1550–1950.* London: Shire, 2012.

Eiseman, Leatrice. *Colors for Your Every Mood: Discover Your True Decorating Colors.* Sterling, VA: Capital Books, 1998.

Eldridge, Lisa. *Face Paint: The Story of Makeup.* New York: Abrams Image, 2015.

Etcoff, Nancy. *Survival of the Prettiest: The Science of Beauty.* New York: Anchor Books, 2000.

Fitzgerald, F. Scott. *The Complete Works of F. Scott Fitzgerald: Novels, Short Stories, Poetry, Articles, Letters, Plays & Screenplays.* Frankfurt, Germany: e-artnow, 2015.

———. *The Great Gatsby.* New York: Charles Scribner's Sons, 1925. Reprint, New York: Scribner's, 1988. Quotation taken from the 1988 edition.

Germani, Ian, and Robin Swales, eds. *Symbols, Myths and Images of the French Revolution: Essays in Honour of James A. Leith.* Regina, Canada: Canadian Plains Research Center, 1998.

Grant, Linda. *The Thoughtful Dresser: The Art of Adornment, the Pleasures of Shopping, and Why Clothes Matter.* New York: Scribner, 2010.

Heymann, C. David. *Liz: An Intimate Biography of Elizabeth Taylor.* New York: Atria Books, 2011.

Horn, Greg. *Living Green: A Practical Guide to Simple Sustainability.* Topanga, CA: Freedom Press, 2006.

Jeffreys, Sheila. *Beauty and Misogyny: Harmful Cultural Practices in the West.* 2nd ed., Hove, East Sussex, UK: Routledge, 2014.

Kenny, Erin, and Elizabeth Gackstetter Nichols. *Beauty Around the World: A Cultural Encyclopedia.* Santa Barbara, CA: ABC-CLIO, 2017.

Kiester, Edwin, Jr. *Before They Changed the World: Pivotal Moments That Shaped the Lives of Great Leaders Before They Became Famous.* Beverly, MA: Fair Winds Press, 2009.

Marlowe, Christopher. *Doctor Faustus.* New York: W. W. Norton, 2005.

Marsh, Madeleine. *Compacts and Cosmetics: Beauty from Victorian Times to the Present Day.* Barnsley, UK: Pen and Sword History, 2014.

Maupassant, Guy de. *The Complete Works of Guy de Maupassant.* London: Forgotten Books, 2006.

Mitchell, Margaret. *Gone with the Wind.* New York: Macmillan, 1936. Reprint, New York: Scribner, 2011. Quotation taken from the 2011 edition.

Moorey, P. R. S. *Ancient Mesopotamian Materials and Industries: The Archaeological Evidence.* Winona Lake, IN: Eisenbrauns, 1999.

Nabokov, Vladimir. *Lolita.* Paris: Olympia Press, 1955. Reprint, New York: G. P. Putnam's–Berkley Publishing, 1966. Quotation taken from the 1966 edition.

Pallingston, Jessica. *Lipstick: A Celebration of the World's Favorite Cosmetic.* New York: St. Martin's Press, 1999.

Parker, Dorothy. *Complete Poems.* New York: Penguin Books, 2010.

Pastoureau, Michel. *Red: The History of a Color.* Translated by Jody Gladding. Princeton, NJ: Princeton University Press, 2017.

Plath, Sylvia. *The Unabridged Journals of Sylvia Plath, 1950–1962.* Edited by Karen V. Kukil. New York: Anchor Books, 2000.

Pointer, Sally. *The Artifice of Beauty: A History and Practical Guide to Perfumes and Cosmetics.* Stroud, UK: Sutton, 2005.

Sheumaker, Helen. *Artifacts from Modern America.* Santa Barbara, CA: Greenwood, 2017.

Snodgrass, Mary Ellen. *World Clothing and Fashion: An Encyclopedia of History, Culture, and Social Influence.* Abingdon, UK: Routledge, 2015.

Vreeland, Diana. *D.V.* New York: Knopf, 1984.

Articles

Betts, Hannah. "Marilyn Monroe: The Star with Marbles in Her Bra." *Telegraph* (London), March 13, 2012.

Collins, Lauren. "Sole Mate." *The New Yorker*, March 28, 2011.

Elliot, Andrew J., and Daniela Niesta. "Romantic Red: Red Enhances Men's Attraction to Women." *Journal of Personality and Social Psychology* 95, no. 5 (2008): 1150–64.

Fox, Margalit. "Naomi Parker Fraley, the Real Rosie the Riveter, Dies at 96." *New York Times*, January 22, 2018.

Guéguen, Nicolas. "Does Red Lipstick Really Attract Men? An Evaluation in a Bar." *International Journal of Psychological Studies* 4, no. 2 (June 2012): 206–9.

Hart-Davis, Alice. "Painting on a Brave Face." *Newsweek*, April 13, 2015.

Hochswender, Woody. "Illuminating Man Ray as Fashion Photographer." *New York Times*, September 14, 1990.

Keiffer, Elaine Brown. "Madame Rubinstein." *Life*, July 21, 1941.

Larocca, Amy. "The Dreamy Promise of Female-Run Fashion Brands." *New York*, December 7, 2017.

Nagata, Kazuaki. "'Beni' Maker Aims to Revive Rare Lipstick." *Japan Times*, June 25, 2008.

Nelson, Emily. "Rising Lipstick Sales May Mean Pouting Economy and Few Smiles." *Wall Street Journal*, November 26, 2001.

"The Red Badge of Courage." *Harper's Bazaar*, November 1937.

Sciolino, Elaine. "Sans Makeup, S'il Vous Plaît." *New York Times*, May 25, 2006.

Stephen, Ian D., and Angela M. McKeegan. "Lip Colour Affects Perceived Sex Typicality and Attractiveness of Human Faces." *Perception* 39, no. 8 (2010): 1104–10.

Tannen, Mary. "Hazel Bishop, 92, an Innovator Who Made Lipstick Kissproof." *New York Times*, December 10, 1998.

Young, Katy. "Revealed: The Queen's Favourite Beauty Products." *Telegraph* (London), April 16, 2016.

Radio and Film

Grossman, Ann Carol, and Arnie Reisman, dirs. *The Powder and the Glory*. PBS Home Video, 2009. DVD.

Hughes, Sali. Interview on *Woman's Hour*, BBC Radio Four, October 31, 2016.

Interviews and Correspondence

Barba, Bruno. Email comments, January 17, 2018.

Barbier, Jennifer. Interview, December 18, 2017.

Beattie, Dr. Geoffrey. Interview, January 3, 2018.

Bourdelier, Frederic. Interview, February 1, 2018.

Brown, Bobbi. Interview, January 4, 2018.

Curmi, Janet. Email comments, October 13, 2017.

Demsey, John. Interview, December 15, 2017.

Doucet, Patrick. Interview, January 17, 2018.

Eiseman, Leatrice. Interview, January 5, 2018.

Etcoff, Nancy. Interview, January 9, 2018.

King, Poppy. Interview, December 16, 2017.

Light, Orrea. Interview, January 3, 2018.

Page, Dick. Interview, January 8, 2018.

Picasso, Paloma. Interview, December 13, 2017.

Sui, Anna. Interview, November 15, 2017.

Surratt, Troy. Interview, January 5, 2018.

Tsai, Vicky. Interview, January 26, 2018.

Westman, Gucci. Interview, January 11, 2018.

Print Advertisements

Cyclax. Auxiliary Red Lipstick advertisement, 1939.

Helena Rubinstein. "Everything Your Lips Desire" print advertisement, 1942.

PHOTOGRAPHY AND ILLUSTRATION CREDITS

Page 5: Portrait of Millie Felder, courtesy of the Felder family archives.

Page 6: Renowned fashion illustrator René Gruau, who also worked on commissions for revered brands like Rochas, Balmain, and Givenchy, created this image as part of a project for Dior, 1980s. © 2018 René Gruau: www.gruaucollection.com.

Page 8: Cecil Beaton, *Portrait of Margaret, Duchess of Argyll* (watercolor and pencil on paper), 1934. Private collection/photograph © Philip Mould Ltd., London/Bridgeman Images, © National Portrait Gallery, London.

Pages 10–11: Two Japanese print advertisements for Shiseido. **10:** Shiseido Mizu Oshiroi (Powder Foundation with Water), 1938; **11:** Shiseido Cold Cream, 1939. © Shiseido.

Page 12: Untitled drawing of a woman with a yellow hat by Joe Eula (1925–2004), date unknown. Eula is considered one of the greatest fashion illustrations of the twentieth century. Joe Eula/©Melisa Gosnell.

Pages 14–15: Untitled illustration by Daisy de Villeneuve, date unknown. Private collection/Bridgeman Images.

Page 18: A poster for the 1937 film *The Bride Wore Red*, a comedy in which Joan Crawford stars as singer who pretends to be an aristocrat, aided by fancy clothes and red lipstick. Courtesy of Photofest.

Page 19: Cecil Beaton, *Portrait of Joan Crawford* (pen, ink, and watercolor on paper), date unknown. Private collection/Michael Parkin Gallery/Bridgeman Images © National Portrait Gallery, London.

Page 20: Rita Hayworth in a still from the 1946 film *Gilda*. Album/Alamy Stock Photo.

Page 22: Playing Scarlett O'Hara and Rhett Butler in the 1939 film *Gone with the Wind* made Vivien Leigh and Clark Gable—seen here on the cover of a magazine from the era—global stars. Although this adaptation of Margaret Mitchell's novel is set during the American Civil War, Leigh's makeup reflected the look of the period in which the film was made, including her red lipstick. TCD/Prod.DB/Alamy Stock Photo.

Page 25: Audrey Hepburn as a lady in red in the 1957 film *Funny Face*, in a dress designed by Hubert de Givenchy. Courtesy Everett Collection.

Page 26: *The Application of Lipstick* from *The Principles of Uncertainty* by Maira Kalman. © 2007 Maira Kalman.

Page 28: Although she's not shy about wearing cutting-edge clothing and bold makeup, Rihanna opted for a more traditional look as she arrived at a film premiere in London in 2009. Chris Jackson/Getty Images.

Page 29: Shot in 1936 by Boris Lipnitski, this arresting photograph shows Coco Chanel with her trademark pearls, red lipstick, and self-confidence. © Lipnitski/Roger-Viollet/The Image Works.

Pages 30–31: An untitled illustration of two fashion models by Joe Eula. Joe Eula/© Melisa Gosnell.

Page 32: This promotional shot of Madonna shows several of the style trademarks from the early days of her success: platinum blonde hair, lingerie as outerwear, and red lipstick. Courtesy of Photofest.

Page 35: Man Ray's body of influential work includes many photographs that were originally commissioned by popular magazines including *Vanity Fair* and, in the case of this hand-colored image, *Red Badge of Courage, Harper's Bazaar* (November 1937). *Red Badge of Courage* by Man Ray. © Man Ray Trust/ADAGP-ARS/Telimage-2018; © Man Ray Trust/Artists Rights Society(ARS), NY/ADAGP, Paris, 2018.

Page 36: A vintage German advertising poster for Rot-Weiss cigarettes, c. 1931. Swim Ink 2, LLC/CORBIS/Corbis via Getty Images.

Page 37: A print advertisement for lipstick by Guerlain, which introduced its first tube in 1884. © 1934 Guerlain.

Pages 38–39: Cells of Snow White and the Evil Queen, both vibrantly ruby-lipped, from Walt Disney's first Technicolor film, *Snow White and the Seven Dwarves* (1937). Pictorial Press Ltd/Alamy Stock Photo.

Pages 40–41: Red lips as graffiti, location unknown. Full lips with white interior, taken in downtown New York City © 2018 Millie Felder. Outline of red mouth: Ian Hubball/Alamy Stock Photo.

Page 43: Claudette Colbert as Cleopatra, from the epic 1934 film directed by Cecil B. DeMille. Pictorial Press Ltd/Alamy Stock Photo.

Page 44: The front cover of the July 31, 1919 issue of French weekly journal *La Baïonette* at the height of the suffragette movement and its bold protests in favor of voting rights for women. © Mary Evans Picture Library.

Page 46: An array of lipsticks in various shades of red, testimony to the fact that there's a hue for every woman. © Tom Hartford.

Page 47: This portrait shows just how striking the contrast between red lipstick and features like gray hair can be. istock/Getty.

Page 48: *Black Scarf* by Alex Katz, whose painted portraits of women with lipstick, red and otherwise, are practically a signature element of his work. © 2018 Alex Katz/Licensed by VAGA at Artists Rights Society (ARS), NY. Photograph: *Black Scarf*, 1996 (screenprint), Katz, Alex (b.1927)/private collection/photograph © Christie's Images/Bridgeman Images.

Page 51: Christian Dior print advertisement, date unknown. All rights reserved/Christian Dior Parfums Archives, date unknown.

Page 52: The "Face" dress by Yves Saint Laurent demonstrates the designer's love of art, as did his famous Mondrian Collection of dresses from the same era. Yves Saint Laurent autumn/winter 1966 collection. Mirrorpix/Courtesy Everett Collection.

Page 53: A dress with a red lipstick motif by Hedi Slimane from the Saint Laurent spring/summer 2014 collection. Image © FirstView.com.

Page 55: This Fornasetti chair, "Bocca," is made of wood which is printed, painted, and lacquered by hand. Courtesy of Fornasetti.

Pages 56–57: Painter Francesco Clemente's wife Alba has been a frequent subject of—and inspiration for—his work, including this 1977 portrait. *Alba* by Francesco Clemente. © Francesco Clemente, Courtesy of Mary Boone Gallery, New York.

Page 58: *Portrait of Elizabeth I*, 1935 (lithograph)/private collection/Prismatic Pictures/ Bridgeman Images.

Page 61: A portrait of Queen Elizabeth II taken around the time of her June 1953 coronation. Chronicle/Alamy Stock Photo.

Page 62: A detail from Shepard Fairey's mural of Blondie, painted on the side of a building located off the Bowery in New York City. Artwork © 2017 Shepard Fairey/Obey Giant Art, Inc; photograph © 2018 Millie Felder.

Pages 64–65: Siouxsie Sioux in 1980, the year the Banshees' album *Kaleidoscope* was released. Photograph by Lynn Goldsmith; Lynn Goldsmith/Corbis/VCG via Getty Images.

Page 66: *Four Shades of Red*, a drawing by the fashion illustrator Blair Breitenstein, date unknown. © Blair Breitenstein.

Page 67: This Chanel 1960 color chart was used to present new shades to retailers. It is now part of the brand's archives. © CHANEL.

Page 69: A promotional photograph of Elizabeth Taylor in the 1950s. She's wearing a fur stole that was typical of the period and, of course, red lipstick. Everett Collection.

Page 70: Walt Kuhn, *Woman in Majorette Costume* (oil on linen), 1944. Courtesy of DC Moore Gallery, New York.

Page 71: Walt Kuhn, *The White Cockade* (oil on canvas), 1944. Fred Jones Jr. Museum of Art, University of Oklahoma, USA/Gift of Jerome M. Westheimer, Sr., of Ardmore, Oklahoma/Bridgeman Images.

Page 72: Illustrator Adolph Treidler is best known for his World War II pro-American propaganda posters and artwork for influential magazines from the period, like the *Saturday Evening Post*. This poster exemplifies his work. *Soldiers Without Guns* (lithograph), 1944. Treidler, Adolph (1886–1981)/private collection/Photo © GraphicaArtis/Bridgeman Images.

Page 74: A British woman applying red lipstick during World War II, location and date unknown. © Imperial War Museum (D 176).

Page 76: From the 1920s into the 1940s, cosmetics brand Tangee was especially renowned for its lipsticks. During World War II, the company created a series of print advertisements aimed at patriotic women, including this one from the early 1940s. © Illustrated London News/Mary Evans Picture Library.

Page 77: A print advertisement for Elizabeth Arden's lipstick, Montezuma Red, a color that was inspired by the red hat cord, scarf, and chevrons of the uniforms of the Women in the Marines. Courtesy of Revlon.

Page 78: The famous poster *We Can Do It!* featuring red-lipsticked Rosie the Riveter has inspired women to empowerment since it first appeared in 1942. Pictorial Press Ltd/ Alamy Stock Photo.

Pages 80–81: An image by the fashion photographer Chaloner Woods of two women playing an unusual game of chess, c. 1955. Chaloner Woods/Getty Images.

Page 83, left: A portrait of beauty entrepreneur Elizabeth Arden, 1947. Jerry Tavin/Everett Collection.

Page 83, right: Helena Rubinstein, c. 1940. Everett Collection.

Page 85: A French film poster for *Ecstasy*, starring Hedy Lamarr. Everett Collection.

Pages 86–87: In the late nineteenth and early twentieth centuries, cigarette packages often came with a beautifully illustrated card depicting entertainers, sports figures, or just a captivating image. These images are from cards along those lines. **86, left:** Girl and soldier kissing (color photograph), French photographer, (20th century)/private collection/© Look and Learn/Bridgeman Images. **86, right:** Kissing couple (color photograph), French photographer, (20th century)/private collection/©Look and Learn/Bridgeman Images. **87:** French couple Kissing, c.1920 (hand-colored silver print), French photographer, (20th century)/private collection/Photo © GraphicaArtis/Bridgeman Images.

Page 88: Paloma Picasso at the Hôtel de Crillon, Paris, 1986. © Toni Thorimbert.

Page 91: An advertisement for Paloma Picasso's perfume, which lead to the creation of her luxury lipstick, available in just one shade: vivid red. The Advertising Archives/Alamy Stock Photo.

Pages 92–93: Although this photograph was taken backstage at a buzzing fashion show, it suggests the peaceful calm of a snowy day. © 2018 Kevin Tachman.

Page 94: Raphael Soyer, *Café Scene* (oil on canvas), circa 1940. Brooklyn Museum of Art, New York, USA/Gift of James N. Rosenberg/Bridgeman Images. Reproduced with permission of the Estate of Raphael Soyer.

Page 95: Napkins with a lipstick motif by Jonathan Adler. © 2018 Jonathan Adler.

Page 98: A French film poster for director Stanley Kubrick's *Lolita* (1962). The film's title role was played by Sue Lyon, who won a Golden Globe for her portrayal of Vladamir Nabokov's famous nymphet. Courtesy of Photofest.

Page 101: Marilyn Monroe c. 1953. Marilyn Monroe/Collection CSFF/Bridgeman Images.

Page 102: Dante Gabriel Charles Rossetti, *Snowdrops* (oil on canvas), 1873. Private collection/Bridgeman Images.

Page 105: John William Waterhouse, *Destiny* (oil on canvas), 1900. Towneley Hall Art Gallery and Museum, Burnley, Lancashire/ Bridgeman Images.

Page 106: Dante Gabriel Charles Rossetti, *La Ghirlandata* (oil on canvas), 1873. Guildhall Art Gallery/City of London/Bridgeman Images.

Page 107: Dante Gabriel Charles Rossetti, *Lady Lilith* (oil on canvas), 1868. Delaware Art Museum, Wilmington, USA/Samuel and Mary R. Bancroft Memorial/Bridgeman Images.

Page 109: Fashion icon Diana Vreeland in her signature red lipstick and matching nail polish. Here she is photographed at her New York City apartment in 1982. © Priscilla Rattazzi.

Page 111: An illustration of the consummate flapper, complete with a precisely cut bob, getting ready to go out, c. 1926. © Mary Evans Picture Library.

Page 112: Liza Minnelli won an Academy Award for Best Actress for her portrayal of Sally Bowles in director Bob Fosse's *Cabaret* (1972). The film won eight Academy Awards, including Best Director for Fosse, and Best Supporting Actor for Joel Grey. Everett Collection.

Page 113: Ernst Kirchner, *Erna with Cigarette* (oil on canvas), 1915. Private collection/Bridgeman Images.

Page 115: Portrait of the singer Sade Adu, c. 1980, several years before the release of her band's top-charting debut album, *Diamond Life*. David Montgomery/contributor/Getty Images.

Page 117: Cedric Morris, *Milly Gomershall* (oil on canvas), 1936. Private collection/ photograph © Christie's Images/Bridgeman Images.

Page 118: Wonder Woman has become a symbol of empowered femininity since her introduction in 1941; in this illustration she's accompanied by her trademark accessories, including red lipstick. Sabena Jane Blackbird/Alamy Stock Photo.

Page 119: Catwoman represents a different type of powerful woman: one that uses sensuality as one of her weapons. Here, Michelle Pfeiffer plays the part in *Batman Returns* (1992). © Warner Bros/Courtesy Everett Collection.

Page 120: Wayne Thiebaud, *Lipsticks*, 1964. © Wayne Thiebaud/Licensed by VAG at Artists Rights Society (ARS), NY; Image, Bridgeman Images.

Page 123: An Elizabeth Arden lipstick print advertisement for Pure Red, c. 1955. Jeff Morgan 06/Alamy Stock Photo.

Page 124: Artist unknown, *A Woman with a Beni Brush*, c. 1900–1921. HIP/Art Resource, NY.

Page 127: Artist unknown, cigarette card (color lithograph), Japan, 1915. English School (20th century)/private collection/Bridgeman Images.

Pages 128–129: Illustrations for 1950s French lipstick advertisements by René Gruau. © 2018 Ren Gruau: www.gruaucollection.com.

Page 130: Model with red glittered mouth by Kevin Tachman. © 2018 Kevin Tachman.

Page 131: Bil Donovan, *Dotty Girl* (watercolor and ink), 2007. © Bil Donovan/Illustration Division.

Pages 132–133: An untitled portrait of a woman in a gray dress by Joe Eula. Joe Eula/© Melisa Gosnell.

Page 134: Illustration for the French beauty brand Payot, 1951. © 2018 René Gruau: www.gruaucollection.com.

Page 139: An illustration by the French artist Pierre Simon, a favorite of luxury brands like Nina Ricci and Christian Dior, for a British magazine, 1954. © Illustrated London News Ltd./Mary Evans.

Page 141: Daisy de Villeneuve, *Faces with Multicolored Hair*, date unknown. Private collection/Bridgeman Images.

Page 142: *Black Bob* by Blair Breitenstein, date unknown. © Blair Breitenstein.

Page 144: A publicity shot of Grace Kelly in the 1950s. Diltz/Bridgeman Images.

Page 147: Carolyn Bessette Kennedy at the John F. Kennedy Presidential Library and Museum, Boston, Massachusetts, May 1999. Getty Images, Justin Ide/Boston Herald/ contributor.

Pages 148–149: Guerlain lipstick advertisements. **148:** © 1945 Guerlain; **149:** © 1936 Guerlain.

Pages 150–151: *At the Time of the Observatory, the Lovers* ("A l'heure de l'observatoire, Les Amoureux"), by Man Ray (oil on canvas, 100 x 250.4cm), 1934. ©ARS, NY, Banque d/Images, ADAGP/Art Resource, NY.

Page 152: Lipstick print. © Millie Felder.

Page 160: Untitled portrait of a woman in a large feathered hat by René Gruau. © 2018 René Gruau: www.gruaucollection.com.

HarperCollins books may be purchased for educational, business, or sales promotional use. For information, please email the Special Markets Department at SPsales@harpercollins.com.

First published in 2019 by
Harper Design
An Imprint of HarperCollins*Publishers*
195 Broadway
New York, NY 10007
Tel: (212) 207-7000
Fax: (855) 746-6023
harperdesign@harpercollins.com
www.hc.com

Distributed throughout the world by
HarperCollins*Publishers*
195 Broadway
New York, NY 10007

ISBN 978-0-06-284426-2

Library of Congress Cataloging-in-Publication Data

Names: Felder, Rachel, author.
Title: Red lipstick : an ode to a beauty icon / Rachel Felder.
Description: New York, NY : HarperCollinsPublishers, 2019. |
Includes bibliographical references.
Identifiers: LCCN 2018014249 | ISBN 9780062844262 (hardcover)
Subjects: LCSH: Lipstick—History. | Lipstick—Social aspects.
Classification: LCC GT2340 .F45 2019 | DDC 391.6/3—dc23
LC record available at https://lccn.loc.gov/2018014249

Book design by Raphael Geroni

Printed in China
First Printing, 2019

About the Author

RACHEL FELDER is an author and journalist who has written about beauty, style, and trends for many media outlets, including the *New York Times*, the *Financial Times*, and *Women's Wear Daily* as well as the websites of *The New Yorker* and *Vanity Fair*. She is the author of *Insider London*, *Insider Brooklyn*, and *Manic Pop Thrill* and coauthor of *Fighter* (with Reed Krakoff). Based in New York City, she wears red lipstick every day.